CREATIVE TECHNIQUES FOR

Color Photography

Bobbi Lane

AMHERST MEDIA, INC. ■ BUFFALO, NY

DEDICATION

This book is dedicated to Dave Miles, the original "ROYGBIV" of Ringling Brothers' Circus, the love of my life, for bringing light and color into my life.

Published by:
Amherst Media, Inc.
P.O. Box 586
Buffalo, N.Y. 14226
Fax: 716-874-4508
www.AmherstMedia.com

Publisher: Craig Alesse
Senior Editor/Production Manager: Michelle Perkins
Assistant Editor: Barbara A. Lynch-Johnt

ISBN: 1-58428-104-9
Library of Congress Card Catalog Number: 2002113014

Printed in Korea.
10 9 8 7 6 5 4 3 2 1

TABLE OF CONTENTS

Acknowledgments .5
About the Author .7

INTRODUCTION .8

1. HOW LIGHT WORKS10
The Electromagnetic Spectrum10
Visible Spectrum and Prisms11
Color Vision .12
Wavelength Strength, Sunsets, and Scattering . .14

2. HOW COLOR WORKS17
Additive Colors .17
Subtractive Colors .18
How Film and Processing Works19
 Color Transparency19
 Color Negatives and Color Printing20
Color Viewing Kits .21
Opposites and Absorption22
Color Reproduction Failure22

3. FILMS AND PROCESSING24
General Information About Films24
Color Negatives .24
Color Transparencies .25
Printing .28
Professional vs. Amateur Films28
Processing: Normal, Push, and Pull29

4. COLOR TEMPERATURE33
Kelvin Scale .33
Color of Light Sources
 and Color Film Balance34
Times of Day .35
 Golden Hours .35
 After Sunrise/Before Sunset36
 Midday .36
 Afternoon .38
Weather .42
 Overcast Skies .42
 Rain, Sleet, and Snow44
 Saltwater .45
 Freezing Temperatures45
 Sky Reflecting off Neutral Surfaces46
Fluorescent and High-Energy
 Discharge Lamps46

5. FILTERS AND GELS49
Density .50
UV and Haze Filters .50
Filters for Black & White51
Color Filters and Meters53
 Color-Correction (CC) Filters53
 Conversion and Light-Balancing (LB)
 Filters .54
 Graduated Color Filters55
 Color Temperature Meters58
Polarizing Filters and Neutral-Density Filters . .59
 Polarizing Filters .59
 Neutral-Density Filters62

Gels for Light Sources62
 Light-Balancing Gels62
 Color Correction (CC) Gels64

6. PERCEPTION AND PSYCHOLOGY
 OF COLOR .66
Perception .66
Characteristics of Colors68
 Hue .68
 Brightness .69
 Saturation .69
Color Systems .70
 The Munsell System70
 The Twelve-Hue Color System71
 The CIE System71
Color Harmony .72
Advancing and Receding Colors77
Psychology of Colors78

7. BALANCING LIGHT80
Strobe Light and Sync Speed80
Shutters and Sync Speed81
Calculating Exposure82
Ambient Light .83
Color Balance .83
Practical Examples84
 Beach .84
 Library .86
 Hospital .88
 Boardwalk .89
 Studio .89

8. ALTERNATIVE TECHNIQUES91
Extreme Pushing .91
 Kodak P-160092
 Slide Films .92
Overexposure .93

Movement .94
 Camera Shake94
 Slow Shutter Speeds95
 Spin and Zoom97
 Panning .98
Reciprocity Failure99
 Color Shift .100
Out of Focus .100
Extreme Close-up or Macro101
Mismatched Film and Lights102

9. CROSS PROCESSING105
Negative Film in E-6 Chemistry105
Slide Film in C-41 Chemistry108
Testing Procedures109
 Negative Film109
 Slide Film .109

10. COLOR INFRARED111
Focusing .111
Handling .112
Correct Exposure and Variations113
Color Shifts .115
Filters .116

11. DIGITAL IMAGING119
Digital vs. Film .119
Image Capture .119
Adobe® Photoshop®120
Color Balance .121
RGB and CMYK .121

Resources .122
Index .124

ACKNOWLEDGMENTS

This book would not have been possible without the assistance of many people. It truly is a team effort, and I am grateful to all who contributed their time and energy to helping me.

I'd like to thank:

Amherst Media, particularly Craig Alesse for finding me and encouraging me to write my first book, and Michelle Perkins who made the process easy.

A & I Color Labs in Los Angeles for their help, support, information, goodwill, and friendship—and for being the best E-6, C-41, print, and digital lab in the US. Special thanks to Brian Greenberg for his support; Steve Block at the Annex for coordinating and handling my film; Mario Gomez, Paul Netikosol, and Jun Villapando for their excellent expertise; and Bill Pyne at AIM Downtown for special information on cross-processing and his continued help and support over many years.

Christopher Brown for helping me become a better teacher and for his faith in my abilities.

Calumet Photographic for years of support and wonderful association. Giant thanks to Richard Newman for his wealth of knowledge of all things photographic, and his integrity, passion for teaching, and friendship.

Michael Kennedy of Image Publishing for his immense technical information and for being my sounding board regarding complicated subjects.

Kodak for great films, tons of fantastic information, and many years of support for me, my students, and the photography world.

Lee Filters (particularly John Adler) for their support and information in this project and for use of their superior filters.

Ralph Mercer, my first photography teacher at Brockton High School, for his inspiration, sensitivity, artistic ability, and making the

magic so much fun. It all started with Ralph.

Roscoe, for support and technical information, charts, and great gels.

Steve Rosenbaum of S.I.R Communications for his help with many areas of this book, including information and supplies from Minolta, Cokin Filters, and Foveon; also for his humor, passion for photography, and for being a wonderful, sharing person.

Santa Fe workshops (especially Reid Callanan) for inviting me into their home and allowing me to grow and expand as a workshop leader.

My students, from whom I have learned so much and for keeping me on my toes. This book is for all of them.

And finally (the best for last), Bill Sumner, for being the best mentor, teacher, boss, and friend—and especially for showing me the light.

Photograph by Mark Robert Halper.

*B*obbi Lane is a commercial, travel, and stock photographer. Her multifaceted approach to photography incorporates over twenty-seven years of technical experience with innovative artistic interpretation. Lane shoots primarily people on location for corporate and advertising accounts as well as photographing "real people" and travel for stock. Her stock photography has sold worldwide for use in ads, posters, and billboards. You can view her work and get up-to-date information at her website, www.bobbilane.com.

As a teacher on the regional, national, and international level, she brings insight and enthusiasm to her hundreds of students. Bobbi's excellent rapport and communication with her students inspires and motivates, while her straightforward teaching style reaches students of many different skill levels. Lane, a primary photography instructor for UCLA Extension for sixteen years, was honored as the 1995 and 1998 Outstanding Teacher for Visual Arts.

Bobbi teaches for the International Center of Photography and the New School University in New York City. She continues to lead week-long workshops for the Santa Fe workshops, Calumet, and the Maine Photographic workshops. Bobbi occasionally flies to Los Angeles to teach for both UCLA Extension and the Julia Dean workshops.

Bobbi's clients include: Warner Bros., Samsung, Bose Corp., Neutrogena, Ricon, Mattel, Sears' Tower Skydeck, and the Morro Bay Natural History Museum. Bobbi is a featured writer on lighting for *Photo Techniques* magazine. Her articles and photographs have also appeared in *Petersen's PHOTOgraphic* and *Outdoor Photographer*. Her work is featured in *The Lighting Cookbook* (Amphoto, 1997) by Jenni Bidner. She is fascinated by Native American dancing and music and is currently working on a personal project about Western powwows.

After twenty-five years in California, Bobbi relocated to Connecticut in the fall of 2001 and lives in the country with her fiancé, Dave Miles, and her two cats, Carmen and Squeak.

*C*olor is real. Color is vibrant, bold, exciting, cold, stimulating, enticing, romantic, subtle, invigorating, calming, brilliant, and lively. Colors can be warm or cool, pastel or saturated, mysterious or screaming, disturbing or beautiful. Color is what we see. Black & white is unreality.

Background. My fascination with colors began with the flowers in my mother's garden. I have a distinct memory of the orange poppies growing on the side of our little Cape Cod–style house in Massachusetts. In fact, while every other house in the neighborhood was gray, white, or brown, our house was red—so that stimulation started at an early age! I was a senior in high school when I first became seriously interested in photography. I took a cruise to Bermuda with my sister that year, and the intense blues and greens of the water, the brilliant reds of the hibiscus, and the subtle pinks of the coral blew me away. I loved those photographs, and they truly started me on my path to becoming a photographer.

In college I studied the masters of photography, such as Ansel Adams, Yousuf Karsh, Henri Cartier-Bresson, Margaret Bourke-White, Edward Weston, Walker Evans, and Imogen Cunningham. They all worked in black & white, and from them I learned about tone and detail, composition and design, and capturing the moment.

It wasn't until I enrolled at the New England School of Photography that my explorations into color truly began. Much of the information in this book expands upon what I studied there—the technical and chemical manifestation of color theory, films and processing, filters, printing, gels, etc. The work of the color photographers also intrigued me. Elliot Porter conquered the landscape in color like Ansel Adams did in black & white. Pete Turner electrified and intensified color in the 1960s, as did Richard Avedon. The legendary and prolific

Color is

vibrant, bold,

exciting, cold,

stimulating, enticing,

romantic . . .

Jay Maisel—master of the 35mm color slide (who now only shoots digital, incidentally)—was the most influential on my style and vision. The greatest of all, Ernst Haas, played with color as a parable for the Book of Genesis in his book *The Creation* (Viking Press, 1971). Haas' color literally moves, grows, and expands, creating something greater than the subject and greater than the color. It is art.

Films. This book does not cover the descriptions of individual films since they are constantly changing. Please refer to the manufacturers' web site, like Kodak or Fuji, for general and technical information about their current films. As a general guideline, however, saturated films work best for landscapes and still life, while neutral or warm films work best for skin tones.

Using This Book. Color is passion. And life. And death, too. We live it and breathe it and see it everyday. The challenge is how to capture the essence of all this in photographs. This book will help you do exactly that. I intend to give you the theory and the means to use color as you need to for your own personal vision. This book isn't about photographing a particular subject matter or a manual for achieving a particular style. The information in this book pertains to all kinds of photography whether it's portrait, landscape, or still life.

It's a good idea to read this book in sequence. Each chapter builds upon the knowledge from the previous one. Once you've read the book chronologically, using the individual chapters as reference will work fine. The first half of the book contains how-to techniques, from basic to advanced. The book starts with how to make color accurate or correct, which alone is a huge amount of information. The second half is about how to make color "effective." You can't quite figure out how to screw it up properly until you know how to make it right. Experimenting with cross-processing and color infrared films is easier when you understand the basic principles of how color works.

Finally, even though I have a tremendous scientific background, I do not overload this book with unnecessary technical information. Doing logarithms to plot the curve of the film never helped me take a better picture. This book is designed to give you the information you need to create more effective and powerful images. However, photography is a combination of art and technology. I do believe that with a greater understanding of how things work, greater inspiration and ideas are possible. Most of all, I sincerely hope you enjoy the learning process and are inspired to create!

The challenge is

how to capture

the essence of all this

in photographs.

■ THE ELECTROMAGNETIC SPECTRUM

Simply stated, the electromagnetic spectrum refers to energy that travels in waves. These forms of energy are described by their wavelengths, the distance from the crest of one wave to the crest of the next. Although all of these energies travel at 186,000 miles per second, the fact that their wavelengths vary is important in the pursuit of color photography, since it is the differences in wavelengths that films perceive as color.

At one end of the spectrum are the long waves of radio, whose wavelengths are measured in kilometers. At the other end are the extremely short gamma rays, whose tiny wavelengths are measured in picometers (100 trillionth of a meter). In between these two extremes fall visible light in the 380 nanometers (nm) to 740nm range, flanked by ultraviolet and infrared. The term "light" implies visibility. Therefore, other energies that are not visible are referred to as radiation (although some humans actually have the ability to perceive ultraviolet radiation).

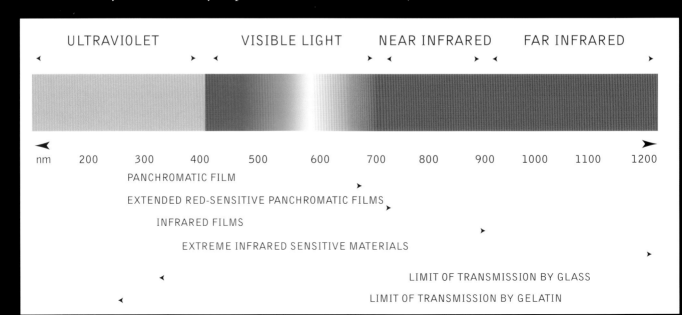

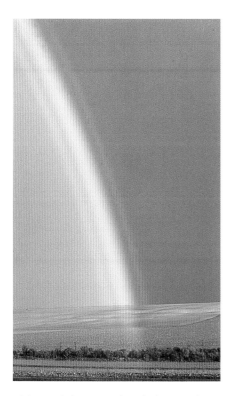

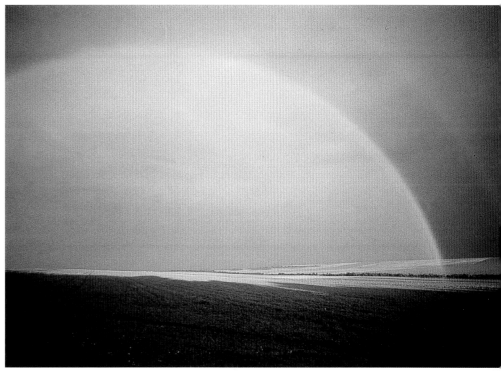

When sunlight passes through the curved surfaces of raindrops, they act as a prism and bend the light so that all of the colors are visible individually.

Keep in mind that even invisible members of the electromagnetic spectrum have photographic applications. For example, there are UV lamps, covered in filters, that absorb visible radiation and are used in conjunction with fluorescent dyes for special effects in stage presentations and photography. Near infrared radiation (700nm to 900nm), can be photographed with specially sensitized black & white or color film. Color infrared photography is covered later in this book.

■ VISIBLE SPECTRUM AND PRISMS

The complete color spectrum of visible light is made up of red, orange, yellow, green, blue, indigo, and violet (the memory device for this is "ROYGBIV"). When all of the wavelengths between 380nm and 740nm (all of the aforementioned colors) are present in fairly equal quantities, we perceive "white" light. We can see how this works by passing a beam of light through a prism, which bends the wavelengths

Passing a beam of light through a prism bends the wavelengths and separates out each component color from the "white" light.

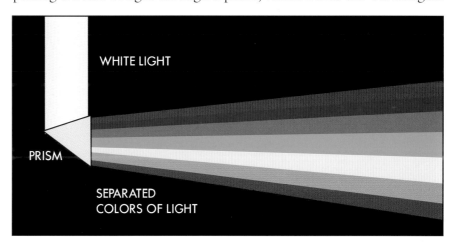

WHITE LIGHT

PRISM

SEPARATED
COLORS OF LIGHT

(see the diagram on page 11) and separates out each component color from the "white" light. This is also how rainbows are created—when sunlight passes through the curved surfaces of raindrops, they act as a prism and bend the light so that all of the colors are visible individually. Although the major (or primary) colors are red, green, and blue, we are also able to perceive the gradual shift of the colors as they change, allowing us to see orange and yellow in the shift from red to green, for example. When we see the colors of light in a rainbow, we are seeing the purest colors possible, since there is no contamination from other light or reflections.

■ COLOR VISION

Exactly how humans perceive color is still not completely understood. However, we do have an idea how our eyes, nerves, and brain work together to allow us to see.

The retina, located at the back of the eyeball, contains two types of light receptors: rods and cones. Rods are only activated in low-light situations and have no color sensitivity. Cones, however, are stimulated by large amounts of light and are sensitive to color. The two work independently and not simultaneously (see the chart below). This is why people sometimes experience temporary blindness when going from outside into a darkroom; as one system closes down, the other starts to function.

Surprisingly, this also means that in certain situations, you can only see in black & white. This startling fact is normally not something we

The retina contains two kinds of light receptors: rods and cones. Rods are activated in low-light situations and have no color sensitivity. Cones are stimulated by large amounts of light and are sensitive to color. Rods and cones work independently, not simultaneously.

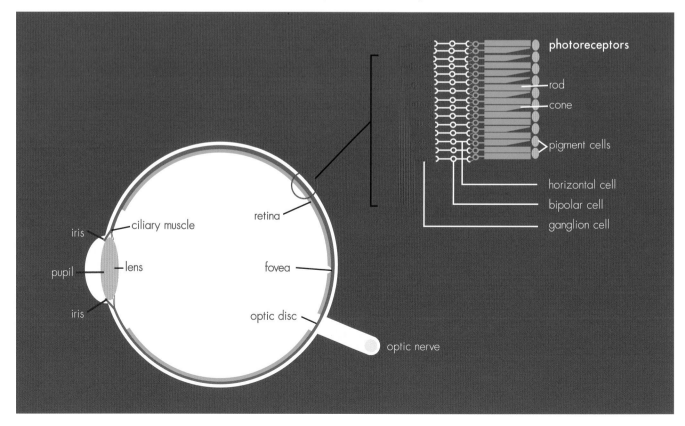

notice, because we are used to seeing in color, and our wonderful brains adapt to the situation. You can experiment with this by sitting in dim light (for example, inside at night with no lights on, and only whatever light comes in the window from a street lamp or the moon) and opening a magazine. Flip through the pages and try to guess what the colors are—you may be surprised at how hard it is to tell, or at the errors you make.

The cones are connected to the brain by a massive network of nerves. As each cone is stimulated, it fires the nerves, sending impulses to the brain for interpretation. Keep in mind that we see all wavelengths simultaneously (in other words, we cannot selectively see only the blue wavelengths). Therefore, it is believed that the light receptors in our eyes have three separate systems that respond to blue, green, and red light with considerable overlap. This is also the basis for color photography, where each layer of the photosensitive film responds to either red, blue, or green.

Once all of this stimulation is sent out, the brain has the incredible job of sorting out all the data into some practical form. Fortunately, the brain is a powerful entity, able to adapt and supply missing information in order for us to function effectively. This ability of the brain to adapt can be demonstrated in several examples. For example, the color of light changes during the day, from warm at sunrise and sunset to cool at midday. Household lamps are much warmer in color than daylight, and fluorescents can actually be greenish. This could create visual confusion (between colors, for example), so our brain balances all of this information to a "white" light condition. As a result, blue still looks blue whether it is under sunlight, incandescent lamps, or fluorescent lights. After all, it would be terribly difficult for us to function if objects seemed constantly to be changing color.

There are times when you can witness the brain adapting. If you look out the window at twilight, everything may look a little cool—but your brain will soon adapt to make that light appear normal. When you turn on a household lamp, light usually appears very orange for a few seconds. As your brain adapts, though, the light appears white.

The next is my all-time favorite example of the power of adaptability. I first heard about this experiment in the 1970s, and recently read that it had been repeated. As light is focused through the lenses in our eyes, the image appears upside down on the retina (just as in a pinhole camera). So our vision is presented to us upside down and the brain corrects it. In this experiment, the subjects were fitted with inverse vision glasses, wrapped tightly to their heads so that all the light they saw came through the glasses. As you can imagine, it was disorienting to see upside down. After a certain amount of time, a few days or a week, the subjects began to see right side up with the glasses still on. The brain had decided that this unusual condition wasn't going away, so it adapted and corrected the orientation. After a few more days, the subjects

removed the glasses and they saw upside down! Again, the brain needed another few days to sort it all out, and everyone saw normally again.

Why is this important? Well, unlike our very adaptable eyes, the camera has no brain. As a result, it accurately records whatever it is pointed at. We need to be very aware of the mind's adaptability in order to create effective photography. I tell all of my students that we need to be as stupid as the camera, truly seeing what is in front of us.

■ WAVELENGTH STRENGTH, SUNSETS, AND SCATTERING

In the electromagnetic spectrum, the longer the wavelengths are, the stronger they are. The kilometer-long radio waves, for example, are still traveling through space, transmitting old radio programs to star systems light-years away.

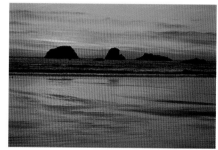
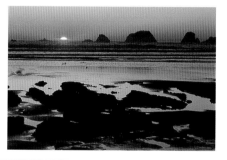

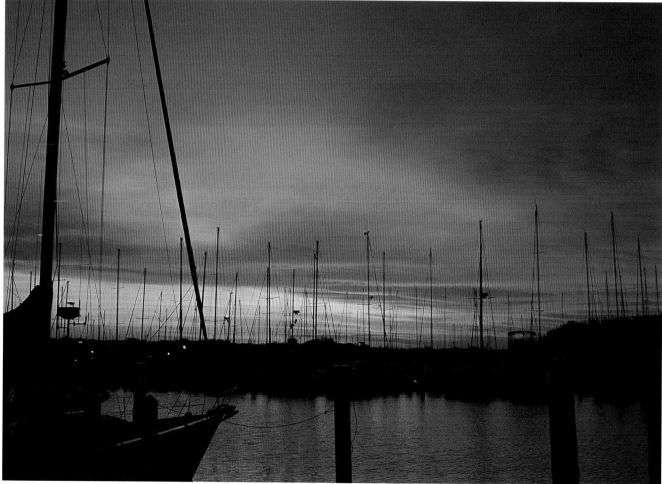

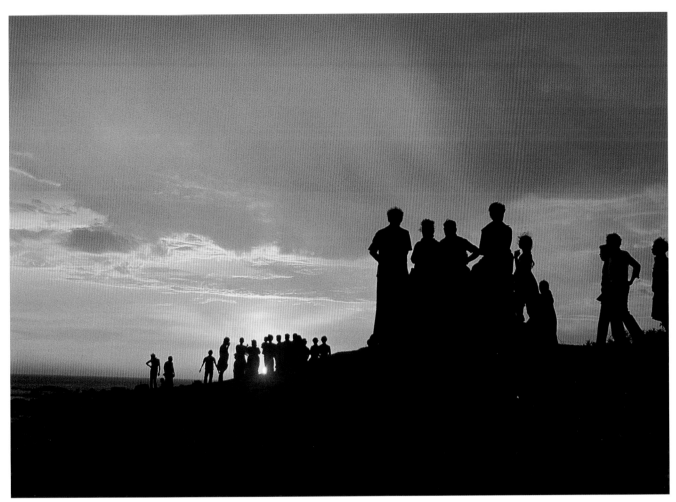

We can't predict the color of the sunset because of all the continually changing variations in the condition of the atmosphere.

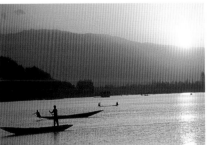

Even though the visible spectrum is made up of only wavelengths from about 400 to 700nm, there is still a difference in strength from the short to the long range. The blue and purple colors fall in the short end. The orange and red waves are longer and also stronger.

Now, consider that the atmosphere is made up of particles and gases. When the shorter wavelengths strike the particles, their weaker light is more easily scattered. As a result, the sky is blue because of the scattered blue light. When the atmosphere is very clear, the sky is a dark, rich blue because pretty much only blue waves are being scattered. When there is a lot of dust, moisture, etc., the sky is white—the greater atmospheric obstructions cause light from even the stronger wavelengths to be scattered, too. On the moon, there is no atmosphere to scatter light, so the sky is black.

For this same reason, sunsets—both the sun and the color of the light—are reddish. At sunrise and sunset, the sun is at an oblique angle to the earth, and the light must pass through a greater depth of atmosphere (see the chart below). Since the red wavelengths are stronger, they are able to penetrate, while the blue light gets more scattered. Still, we can't predict the color of the sunset because of all the continually changing variations in the condition of the atmosphere. Sometimes the conditions are such that the sky remains blue or neutral until the sun drops below the horizon, then the oblique angle of the rays lights up the clouds with warm colors.

This same phenomenon also explains why landscapes viewed from a distance often appear hazy blue. It is because we are looking through all the scattered light that exists between the reflected light from the subject and us.

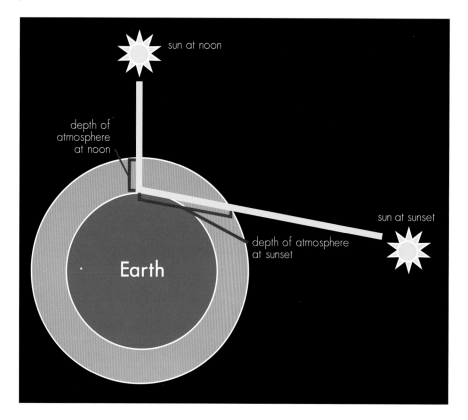

Sunsets and sunrises are reddish because the position of the sun means that the light must pass through a greater depth of atmosphere. The stronger red wavelengths can penetrate this, while the blue ones get scattered more easily.

This chapter describes how light and photography work on a practical basis. The additive and subtractive systems are how all film, processing, and filters function. For that reason, even photographers who only work in black & white need to understand these principles. Artists familiar with pigments and accustomed to mixing certain paints together to achieve other colors may find the information on additive colors confusing, but remember—this is about the nature of light, not paint.

ADDITIVE COLORS

As mentioned in the previous chapter, white light directed through a prism refracts into many different colors (ROYGBIV). The additive sys-

Red, green, and blue are called the additive primary colors. Yellow, cyan, and magenta are the subtractive primary colors. Colors that are directly across the wheel from each other are called complementary.

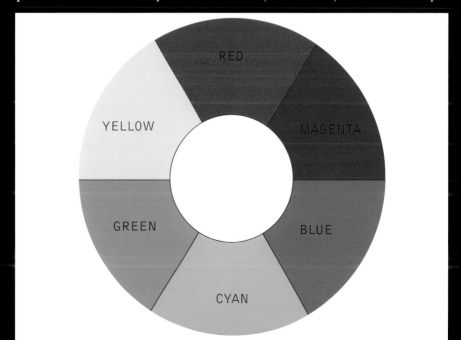

tem consists of three primary colors: red, green, and blue. Each of these colors represents about one-third of the visible spectrum.

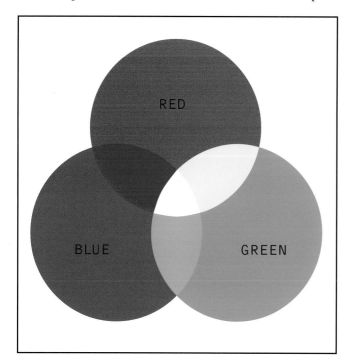

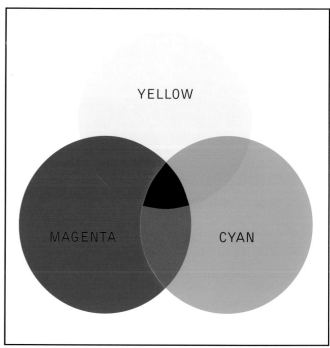

■ SUBTRACTIVE COLORS

The subtractive colors are the pigments or dyes that absorb the additive (light) colors. The primary subtractive colors are yellow, magenta (purplish-pink), and cyan (bluish-green). When equal amounts of yellow, magenta, and cyan are mixed together, black is achieved (at least theoretically, since pigments rarely interact as precisely as light). When yellow, magenta, and cyan are all absent, the result is white (think of blank printing paper).

The subtractive colors are the opposites of the additives, and it's extremely important to understand their placement on the color wheel, both in terms of the positions of opposites and adjacents (see previous page). A useful memory device for their placement is "RC-BY-GM"— "Red Corvette BY General Motors."

The method by which the subtractive colors work is that each subtracts (blocks, absorbs, or cancels) its opposite and allows the other colors to pass. Magenta blocks green light and allows red and blue to pass. Therefore, magenta equates to equal amounts of red and blue light. Cyan blocks red, allowing green and blue to pass. Yellow blocks blue, allowing red and green to pass; therefore, yellow equates to equal amounts of red and green. (Remember, this refers to light [subtractive colors], not pigments [additive colors]!)

The reason yellow, magenta, and cyan are called subtractive is because they subtract (or block) one of the three additive colors that make up white light. For example, a magenta filter placed over a camera lens blocks the green part of white light, but allows the red and blue light to pass. Combining yellow, magenta, and cyan filters results in

black (or neutral density), because each of the primary additives has been blocked (or subtracted). As a result, no light can pass. Therefore, Y + M + C = ND (neutral density). It's okay to combine two subtractive filters, but adding the third just results in decreasing the amount of light.

■ HOW FILM AND PROCESSING WORK

Color Transparency. All color film, whether transparency or negative, consists of three layers of emulsion, each one designed to be sensitive to only one of the additive colors. Because all of the layers are actually sensitive to blue light, the top layer functions as the blue layer. A yellow filter is then placed directly beneath it to prevent any blue light from traveling to the underlying two layers and making an exposure on them; green is in the middle; and red is on the bottom.

Color reversal film, also referred to as transparency or slide film, starts off as a triple-layered black & white negative. When the film is exposed, each layer records a monochromatic representation of the

As light passes through negative film, the various colors are either absorbed or transmitted through each layer. When processed, dyes of the opposite colors collect in the film layers.

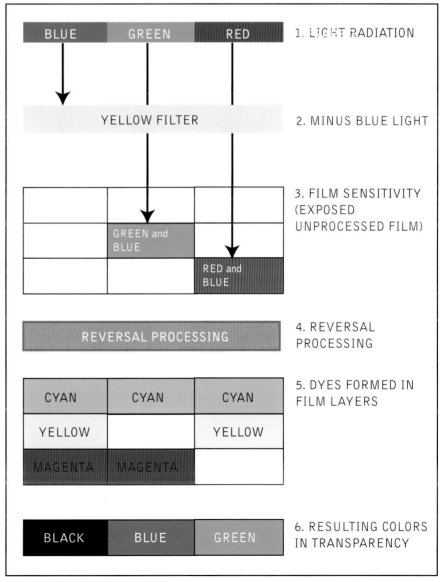

scene or subject based on the amount of light that reaches each area and according to its own color sensitivity. Anything in the scene that reflects red light makes a latent image on the red layer of the negative—and the same is true for blue and green. If the subject is blue, it produces a latent image in the blue layer. If the subject is white, it is recorded in all three layers of the negative.

When the film is developed, the first developer converts the latent image to metallic silver—essentially creating three black & white negatives with the greatest density in each layer matching the color to which it is sensitized. The second developer, called the color developer, contains a chemical that reverses the image and oxidizes the unused silver in the unexposed areas.

This activates the dye couplers, which attach to the areas with the newly oxidized silver. These are subtractive dyes, so the layer that is sensitive to blue has yellow dye, the green layer has magenta dye, and the red layer has cyan dye.

The next step is a bleaching process that reduces and eliminates the exposed silver, leaving behind only the dyes in each of the layers.

A slide is viewed by passing light through it. Since the dyes are subtractive colors, they block their complementary additive colors and allow the intended colors to come through. For example, the blue subject now has cyan and magenta dyes in the corresponding area of the slide and no yellow dye. When light is passed through the slide, red and green light are blocked by the cyan and magenta dyes, allowing only the blue light to pass.

Color Negatives and Color Printing. Color negatives work in a similar fashion to transparencies, except they are in negative form: what's light is dark in the negative, and the colors in the negative are complementary.

The next step with a color negative is the printing process. Like film, color paper has three layers of color sensitivity and must go through a chemical process as well. We perceive the correct colors in the print because the dyes in the paper absorb the opposite color. The reason a print is blue in a specific area is because the dyes absorb red and green light, allowing blue to reflect back to the viewer.

A color head enlarger contains all three subtractive colors in various densities. Normally, two filters (yellow and magenta) are used in the printing process to control the color balance in the print. As mentioned previously, we can't use all three subtractive filters at once, because it would just cause a neutral density.

The Type C printing process, which is from a color negative, requires the printer to think in opposite colors. If the print is too yellow, then yellow must be added to the filter pack, or blue subtracted. The reason for this is that the excess yellow in the print is actually the result of too much blue in the negative. Adding yellow to the filter pack reduces or blocks this excess blue and makes the print less yellow.

When the film

is developed,

the first developer

converts the latent image

to metallic silver . . .

Each step is an opposite: the real world is in positive form, processing the film produces a negative; the negative goes into the enlarger and is projected onto Type C paper, ending up as a positive. Type R printing, from a color transparency, is a reversal process. The slide is placed into the enlarger and Type R paper is used, so it's a positive-to-positive process. The same filters are used, but in this case, if the print is too yellow, then yellow is removed from the filter pack.

■ COLOR VIEWING KITS

In order to judge the color balance of either a print or a transparency, it's helpful to use a color viewing kit. The Lee Color Viewing Kit is a package containing filters of eight densities in the six colors. These surround a clear center. To use the filters to judge the color balance of a print or transparency, you view the photo through an opposite color filter. If you think that the print is too blue, for instance, then look through the yellow filter; if it's too cyan, then use the red filter, etc. How much excess color there is will determine which density you'll need to use to compensate for it.

The Lee Color Viewing Kit is a package containing filters of eight densities in the six colors. These surround a clear center.

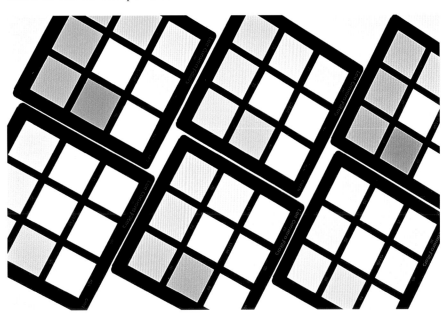

To use the viewing filters effectively, close one eye and look at one spot on the print or transparency. Hold the viewing filter three to four inches in front of your eye. While still focused on the one spot, quickly move the filter out of view and back again, holding each position for about two seconds. This technique forces the eye to perceive the colors correctly without the brain interfering or compensating.

It's helpful to have a test photograph of a gray card on the same roll of film that you are printing. It's easier to judge the color balance of gray because when it's neutral, all other colors fall into place. Otherwise, pick a neutral and medium tone, like skin. It's very difficult to judge color balance on a light or dark area because color shifts with density.

■ OPPOSITES AND ABSORPTION

All of this opposite thinking can be confusing, but so much of the photographic craft is based upon it. The entire color theory system consists of only six colors. An understanding of how these colors work is crucial to the photographer for using filters, when printing, and throughout the reproduction process. This is true both in enhancing the art of photography and mastering the technical aspects of the craft.

The reason that objects have color is because they absorb different wavelengths. An apple is red because it absorbs the blue and green from white light and red is reflected back. This can vary according to the material's physical structure and surface characteristics as well as its dye properties. Some polished metals, like copper, gold, or brass, have "selective reflection" due to their specular nature and favor yellow and red light.

The reason that objects have color is because they absorb different wavelengths. An egg is white because it reflects back all of the colors from white light. An apple is red because it absorbs the blue and green from white light and red is reflected back.

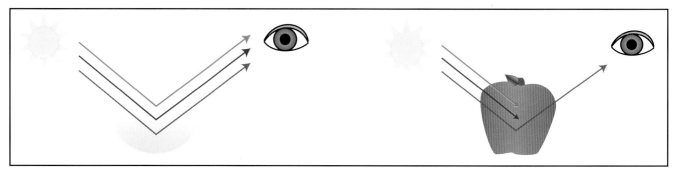

■ COLOR REPRODUCTION FAILURE

Color films are not sensitive to the same wavelengths as the human eye, so occasionally we are surprised at how a color reproduces in our photographs. Films are also more sensitive to UV radiation, which sometimes results in UV-reflecting materials photographing with a blue cast. This is a common occurrence with neutral fabrics that have low saturation, like a black tuxedo. Many fabrics use dyes that play havoc with correct reproduction. Some absorb UV and reemit it in the short wavelengths, resulting in a blue cast on white fabrics. There are several laundry detergents that also contribute to this effect, especially Tide®. If you are photographing under a UV "black light," this is a handy trick to know, because the colors will fluoresce. In both of these cases, using a UV filter on the lens or a UV gel on the light source will lessen the effect considerably.

One of the biggest color problems faced by photographers is called "anomalous reflectance." This is a result of high reflectance at the far-red end of the spectrum, where the human eye has very little sensitivity. If you have ever photographed a blue morning glory and it didn't reproduce as that beautiful blue color you saw in the scene, you have experienced this particular kind or color failure.

I have run across anomalous reflectance several times, always with the color green. Some organic dyes have high reflectance in the far-red end of the spectrum. I've seen this both in paints and in fabric dye. The

resulting color is neutral, or sometimes even warm. My first experience with this was with a green painted rocking chair. We photographed it with green gels, under fluorescent lights, and with polarizing filters on both the camera and the lights—and it still wasn't green! The polarizers seemed to work the best, using Kodak's Ektachrome 100 EPN film, which produces truer color with problem materials.

The other recent example I ran into was when photographing several people, one of whom was wearing a green shirt. These people are the lab managers at A & I Color Lab in Los Angeles, so I had each wear an additive color: red, green, and blue. The green shirt appeared to the eye as a rich kelly green, but photographed a dull gray-green. There was no way to tell in advance, even by shooting Polaroid, because Polaroid's colors are not accurate. Considering the importance of the colors to these people, I bought T-shirts, tested them first, and reshot the photo.

In the photo on the left, the green shirt appeared to the eye as a rich kelly green, but photographed a dull gray-green. To fix the problem, I bought T-shirts, tested them first, and reshot the photo.

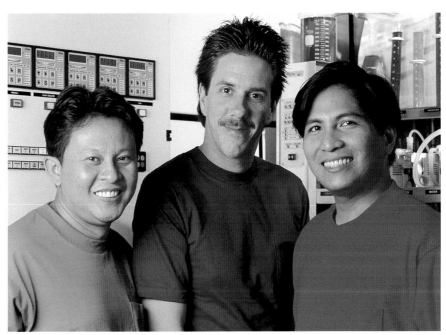

3. FILMS AND PROCESSING

GENERAL INFORMATION ABOUT FILMS

This chapter does not cover the descriptions of individual films since they are constantly changing. Please refer to the manufacturers' web site, like Kodak or Fuji, for general and technical information about their current films. As a general guideline, however, saturated films work best for landscapes and still life, while neutral or warm films work best for skin tones.

COLOR NEGATIVES

Color negatives are designed and processed to produce an image that is the opposite of what the viewer perceives. Whatever is light in reality is dark on the negative, and what's dark is light. The colors rendered in the negative are also complementary, so that what is green in the scene is magenta on the negative. To reverse the colors so they appear realistic in the print, the negative is placed into an enlarger. Light is then focused through it onto color paper and developed back into a positive image. Color negative films are processed in C-41 chemistry, and the prints are called Type C.

Although there is some variation, most negative films have a five-stop contrast range. This is the difference in the amount of light between the lightest highlight area that retains detail and the darkest shadow area that retains detail. This wide contrast range provides a smooth transition from light to dark. Photographing under either bright or soft lighting conditions will render good results.

Exposure is forgiving in negative films because of this great range, but when in doubt, it's always better to overexpose to ensure good shadow detail. A negative can be under- or overexposed by about a stop and still make a print with full tonality.

Because of the lower contrast they offer, negatives are a good choice for portraits, rendering smooth and creamy skin tones.

Negatives are a good choice for portraits, rendering smooth and creamy skin tones.

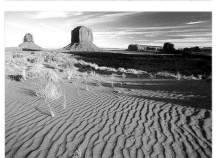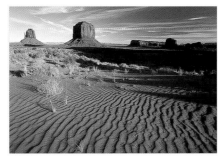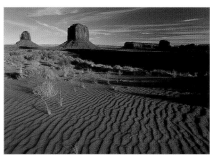

TOP—This scene was bracketed in half stops under flat light (left=+½ stop, center=N ["normal"] exposure, right=−½ stop). BOTTOM—This desert scene in Monument Valley was photographed in direct sunlight. I bracketed in half-stops (from left to right: +½, N, −½). The normal (N) exposure still has detail in the shadows, but the −½ stop exposure has more saturation. I don't mind losing detail in the shadows because these areas are not important here, just a graphic element of composition.

■ COLOR TRANSPARENCIES

Transparencies, chromes, slides, and reversal materials are all positive media. With these materials, the film in the camera is designed and processed to provide an image that is viewed by passing light through it, usually with the use of a slide projector or a light table.

The contrast range of chromes is only three stops, creating a more contrasty but also a more saturated color image. Photographing under fairly even lighting conditions and making correct exposures is crucial. Over- or underexposing a chrome by one stop will result in an unacceptable image.

Bracketing (using several different exposures) by a half-stop in both directions is the best solution. In an evenly lit scene, all three exposures will be good, but each will have a different feeling. There will also be a slight color shift with exposure. The lightest exposure will be a little pastel and have a softer feeling, while the darkest one will have the most saturation and will be dramatic. Even with the advanced technology of camera light meters today, they can still be fooled, and there's nothing worse than having a potentially great shot ruined because the exposure was slightly off. If it's worth taking the picture, it's worth taking three.

Bracketing is especially important when photographing people, because skin tones will always look more flattering when they are lighter

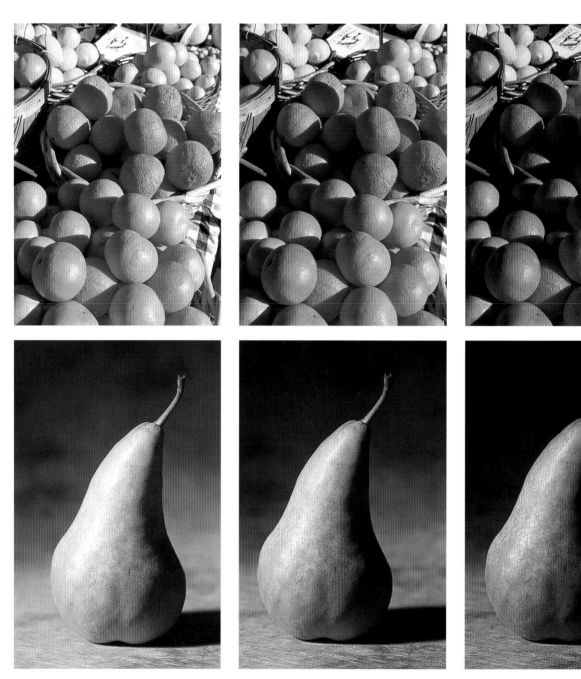

TOP—Bracketing in the sun (left to right: +½, N, −½). BOTTOM—Bracketing in studio spotlight (from left to right: +½, N, −½).

than normal—one-half to one stop overexposed. However, a character portrait should be exposed exactly or even a little under for more texture, detail, and saturation.

Since slides are the reverse of negatives, the general rule is, when in doubt, underexpose. An overexposed slide looks washed out, desaturated, and faded. If there is no information in the film, no other process can create what's not there. However, if a slide is just slightly underexposed, it can be compensated for in the print, or an internegative can be made to bring out the shadow detail.

The question is, with all of these limitations, why bother with the difficulties of transparencies? Why not just shoot negatives? The reason is that transparency films are manufactured to provide the best and most accurate color, saturation, grain, sharpness, choices in qualities of mate-

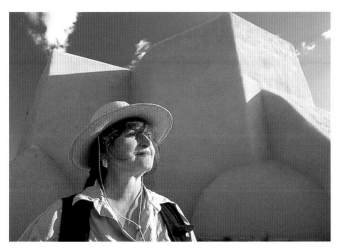
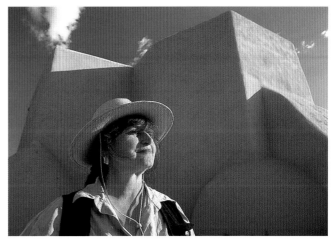

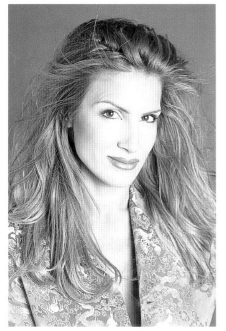
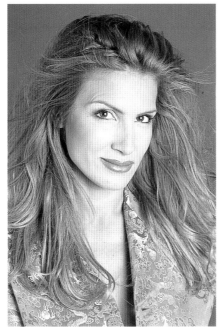
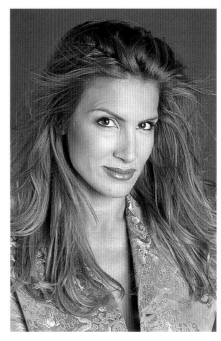

TOP—This portrait was bracketed at +½ (left) and N (right). She looks better +½. MIDDLE—This studio portrait was bracketed at +1 (left), +½ (center), and N (right). In the normal exposure, the skin tones are too rich, but both of the other exposures work. BOTTOM—This portrait was bracketed at +½ (left) and N (right). He's a character, so the normal exposure is better.

rials, scanning characteristics, and consistency. Until recently, almost all of the photographs reproduced in magazines, books, calendars, posters, etc., were made based on transparencies. With the advent of digital technology and reproduction methods, this is changing, though.

■ PRINTING

There are two ways to make photographic prints from slides. The Type R (for "reversal") print is a positive-to-positive process. The slide is placed in the enlarger and projected onto Type R paper. There is no negative in the process. Many manufacturers make paper and chemistry for this process. All of these processes will, however, increase the contrast in the print—sometimes losing some of the highlight or shadow detail. Ilford, for example, makes Ilfochrome, a high quality paper with corresponding chemicals that are super saturated and offer excellent longevity. It is a very contrasty process, but can be controlled by altering the developing process.

If the slide already has a good amount of contrast and it's important to retain the detail, the slide can be projected onto internegative material. An internegative is a 4" x 5" piece of film that is specially designed to hold detail and sharpness. A custom Type C print can then be made from this internegative. Although this does add an extra generation, the size of the internegative helps to maintain the sharpness and detail quality. The surface of the paper matters quite a bit in the final results. Glossy paper retains the highest degree of sharpness and saturation. Matte paper, since the surface is actually textured instead of smoother, makes a softer image, in terms of both sharpness and color. Matte paper also doesn't have the ability to produce a rich black.

■ PROFESSIONAL VS. AMATEUR FILMS

Film is an active medium. Although the film base is neutral acetate, the complex chemicals used in the emulsion will age and change over time.

Professional films are manufactured to meet certain criteria including: color balance, exposure accuracy, sharpness, and grain. The films are produced, stored, and aged until these strict requirements are met,

then refrigerated and released to the dealers. The films should be stored either in the refrigerator or freezer until ready for use and processed as soon as possible after exposure. Subjecting film to intense heat or high humidity can cause color shifts as well.

SIZE	Warm-up time (hours) to reach room temperature of 70°F (21°C) from a storage temperature of:		
	0°F (−18°C)	35°F (2°C)	55°F (13°C)
Roll	1	.75	.5
135 magazine, 110, 126 cartridge	1.5	1.25	1
35mm long roll	5	3	2
70mm long roll	10	5	3
10-sheet box	1.5	1	1
50-sheet box	3	2	2
100-sheet box	4	3	2

Amateur films are also manufactured to a high standard, but with an added bias that helps to prevent major color shifts over a long period of time. This is necessary because amateur photographers may keep their camera in the car for months, exposing it to high heat, and still expect to get good colors from their local processor. This built-in bias prevents the films from reaching the professional color standards.

For all films, the emulsion number and expiration date are printed on the side of the box. The number is the batch number; the date on the package is the last date that, if the film has been properly stored, the manufacturer will guarantee color accuracy and speed. Some art photographers prefer outdated film because the colors are no longer accurate and, thus, odd effects can be created.

■ PROCESSING: NORMAL, PUSH, AND PULL

Under normal exposure and processing procedures, X amount of light equals X amount of density on the film. While different films have different characteristics—some films produce more shadow detail or have a great contrast range, etc.—in most cases, exposing the same way under similar conditions will produce the same results in the density of the film.

Altering the process by pushing or pulling (changing the development time) will vary both the density and contrast. Pulling refers to decreasing the development time, and pushing refers to increasing the time. In both negative and chrome films, a longer time in the developer produces a lighter density.

We normally think of pushing film as the combined process of underexposing in the camera and overdeveloping in the chemistry. For example, a 200 ISO film exposed at 400 ISO and processed normally

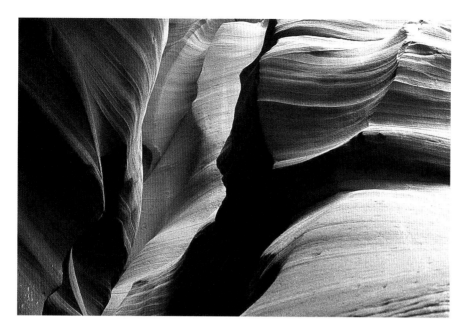

The photos to the left were shot on Kodak P-1600 film rated at 1600.

would result in the film being dark, because it was one-stop under-exposed. (Remember, whenever a number is doubled or halved, there's a difference of one stop.) To compensate, the development time needs to be increased (or pushed) by a percentage of time that is the equivalent of one stop. Therefore, we tell the lab to push one stop (or +1). The truth is, the term "pushing" only refers to how the film is processed, not exposed. As a photographer, you can rate the film any way you want; therefore, telling the lab only that you rated the film at 400 ISO really means nothing to them. They can assume that you want the film pushed, but that is an assumption. You could choose to rate the film at 320 ISO and still want it processed at +1; you could even rate it as indicated at 200 ISO and want it developed at +1 for effect. The exception to this are the high speed films, like Kodak P-1600, which are meant to be pushed. With these films, you mark the exposure you used on the canister, and the lab develops the film accordingly.

During the development process, the middle and darker tones develop first, and the lighter or highlight tones develop last. After the first half of "normal" development time, the darker tones have developed as much as they are going to, and the highlight areas haven't even really begun to develop. Therefore, since it's the second half of the process that controls the highlights, the longer the development time, the lighter the highlights get. This is why pushed film has more contrast—the highlights are lighter. If the development time is increased considerably, more than +1, the middle and shadow tones will get lighter, too, but proportionately less than the highlights.

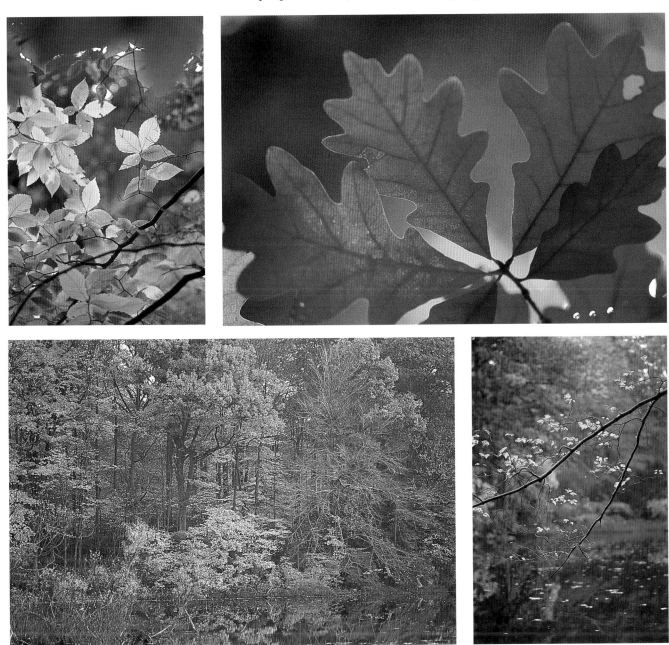

TOP (LEFT AND RIGHT)—Kodak E-200 was rated at 400 and pushed 1⅓ stops. BOTTOM (LEFT AND RIGHT)—For this fall scene in deep shade, Kodak E-100 VS was rated at 200 and pushed one stop.

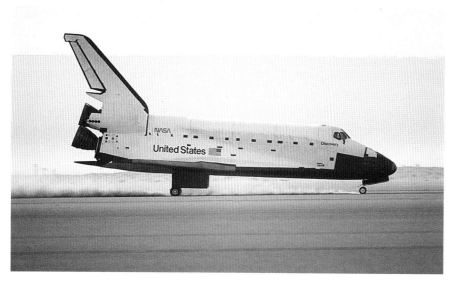

Keep in mind that color balance will also change with long development times, and some films are more sensitive to this shift than others. For example: Kodak's E-100 G, GX, VS, and E-200 are known for their ability to maintain color balance up to a one or one-and-a-half-stop push. Kodak's EPP—Ektachrome Professional Plus (100)—a long-time professional favorite known for its neutral but rich colors, begins to shift color with a one-stop push.

In a negative, the longer the processing, the more silver is laid down. As a result, extra developing makes light-gray areas darker (or denser) in the negative. This blocks more light in the printing process, rendering the light areas lighter in the print. The same process happens in chrome films. More silver is laid down in the highlights. This is then reduced by the bleach and hypo, leaving the film clear.

The following rule, then, applies to both negative and chrome films: exposure controls shadows and development controls highlights. Understanding this process gives the photographer a greater amount of control over the results of the film. For example, an editorial portrait photographer who shoots mostly slide film for magazines can push the processing by one-third- or a half-stop, effectively lightening skin tones. This makes a flattering portrait without losing the saturation of the middle and darker tones. If the film were overexposed by a half-stop, all of the colors would equally be lighter. By pushing the film, only the highlight areas—in this case, the skin tones—are made lighter. A head-shot photographer photographing models and actors in black & white can also use the same method. By overdeveloping the film by a half-stop, the skin gets lighter with a little less detail.

When the processing is pulled, such as −1, the highlights don't have a chance to develop fully. This results in a flatter look with less contrast, and colors that are not as bright. Kodak's E-100 G, GX, VS, and E-200 can be pulled one stop without much loss of color. This is a great trick in a contrasty scene, but is not recommended on a regular basis, because you will still lose color saturation.

■ KELVIN SCALE

In the previous chapters you learned that equal amounts of red, green, and blue light make up white light. The truth is, there is no such thing as white light. Great! All that effort trying to understand what white light is, and now you tell me there's no such thing? In truth, all light has color. This is called its color temperature and is measured in degrees on the Kelvin scale, just like we measure heat by degrees Fahrenheit. For example, the bluish color temperature of daylight is 5500K, while the more orange color of tungsten floodlights is 3200K.

APPROXIMATE CORRELATED COLOR TEMPERATURE FOR VARIOUS LIGHT SOURCES

ARTIFICIAL LIGHT		DAYLIGHT	
Match flame	1700°K	Sunlight (sunrise or sunset)	2000°K
Candle flame	1850°K	Sunlight (one hour after sunrise)	3500°K
40-watt incandescent tungsten lamp	2650°K	Sunlight (early morning)	4300°K
75-watt incandescent tungsten lamp	2820°K	Sunlight (late afternoon)	4300°K
100-watt incandescent tungsten lamp	2865°K	Average summer sunlight at noon (Washington, D.C.)	5400°K
500-watt incandescent tungsten lamp	2960°K		
200-watt incandescent tungsten lamp	2980°K	Direct mid-summer sunlight	5800°K
1000-watt incandescent tungsten lamp	2990°K	Overcast sky	6000°K
3200° Kelvin tungsten lamp	3200°K	Average summer sunlight (plus blue skylight	6500°K
Molarc "Brute" with yellow flame carbons and YF101 filter (approx.)	3350°K		
"C.P." (color photography) studio tungsten lamp	3350°K	Light summer shade	7100°K
		Average summer shade	8000°K
Photoflood or reflector flood lamp	3400°K	Summer skylight will vary from	9500–30000°K
Daylight blue photoflood lamp	4800°K		
White flame carbon arc lamp	5000°K		
High-intensity sun arc lamp	5500°K		
Xenon arc lamp	6420°K		

 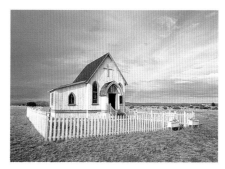 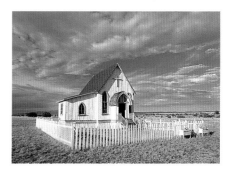

The color of light ranges from cool (bluish) to warm (reddish). It is very important to understand that, when we talk about blue light, we are not referring to the actual color of blue as in the additive system, but the coolness of the light source. On the Kelvin scale, the higher the number, the cooler the light; the lower the number, the warmer the light. The scale is not proportional, though, so a change of 1000 degrees at the high end is a small difference, but even a 100-degree change at the warm end is quite noticeable.

The color of an overcast sky varies from 6000K to 8000K, and open shade or skylight ranges from 8000K to 12000K. Most color films will record anything over 5500K as slightly cool, not as drastically blue.

At the warm end, the 400-degree difference from tungsten (3200K) to a 100-watt incandescent bulb (2800K) results in a perceptible color shift on the film.

We can use a color temperature meter to read the actual Kelvin degree of any situation. You will learn more about meters in the next chapter.

Here we see three shots made within half an hour of each other. The first image (left) was made in deep overcast light; the second image (center) was created under light haze as the sun burned off the clouds; the third (right) was made under a cloudless sky in the warm light of late afternoon.

■ COLOR OF LIGHT SOURCES AND COLOR FILM BALANCE

Recording colors accurately on the film depends upon many aspects, with color temperature being the main factor.

We have two primary kinds of film to choose from: daylight-balanced film is designed to give good color under bluish light, while tungsten-balanced film is designed for warm or orangish light. Each is manufactured to gives us "accurate" color when exposed properly under the matching light source.

Most photographers are used to working with daylight film for available light or strobe light. Strobe light is the same color as daylight, having a range of 5000K to 5500K (some strobe manufacturers construct their lights so that it is possible to vary the color temperature by as much as 400 degrees). Under these lighting conditions, daylight film renders colors correctly.

Tungsten film is balanced for light sources of 3200K, such as floodlights, stage lights, and halogens. Household lamps use bulbs that are even lower in color temperature than tungsten, so shooting on tungsten film under these lights would still produce a slightly warm photo.

If we were to shoot daylight film in our homes at night with the scene illuminated only by lamps, the photo would have a substantial

A color temperature meter can be used to precisely read color temperatures.

color shift toward orange. Conversely, if we shoot tungsten film outside, the entire film would have a pale bluish cast. As we will see later in the book, using the "wrong" film type can create interesting and effective photos.

■ TIMES OF DAY

We cannot accurately say that daylight is 5500K because so many atmospheric and location conditions factor into the color temperature. The general standard is that a scene in the middle two-thirds of the day (not early or late)—with both direct sun and blue sky as the light source, and not in high altitudes or at the poles—provides the conditions to create 5500K lighting. Unless you are looking for perfect accuracy and need to use a color temperature meter (more on that later), most of the general daylight hours will render colors correctly on daylight film.

The actual color of the sunlight changes drastically throughout the day, spanning the range from about 3000K to 3200K at sunrise or sunset, to 3500K to 3700K one hour after sunrise or before sunset, to 3900K to 4100K at two hours after sunrise and before sunset. The color temperature changes daily depending upon the atmospheric conditions in regard to moisture, dust, and pollution.

The reason for this color shift is based, as previously discussed, upon the strength of the wavelengths of light. At sunrise and sunset, the angle of the sun is oblique to the earth, and the rays must travel through a greater density of atmosphere. When the atmosphere is thick and there is more "stuff" in the sky, only the longer, redder wavelengths are able to penetrate, while the shorter, blue wavelengths get scattered. These variables explain why no two sunrises or sunsets are the same. While the color temperatures in daylight go through the same shifts at sunrise, pollution tends to build up mainly during the daytime, so sunsets are often particularly spectacular.

Golden Hours. Before sunrise, the sky provides plenty of light, but the color is very cool and the quality of light is soft and almost shadowless. The first rays of light are the reddest, slowly shifting into orange and gold. Every landscape and travel photographer relishes this beautiful time for the soft quality and low-angle textures as well as the color that can be achieved. It's also the perfect time for portraits because of the smoother tones of diffused light. Because of these excellent qualities, the first hour of sunlight in the day and the last hour are often called the "golden hours."

In landscape photography, the time just after sunset is sometimes the most interesting because of the soft light bouncing back into the scene. To take advantage of the best light, full-time travel photographers get up before light to begin working, sleep in the middle of the day, and return to shooting in the early evening, working until all the light is gone.

The actual color

of the sunlight

changes drastically

throughout

the day . . .

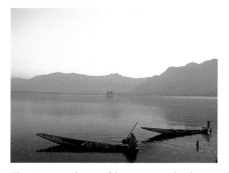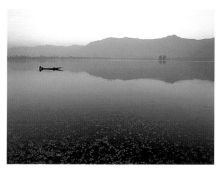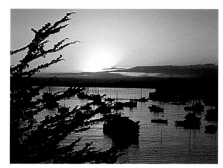

The images above of boats on Dal Lake in India were all taken before sunrise using skylight. On the right is Monterey Bay.

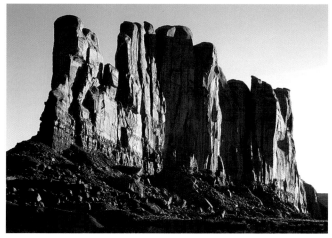

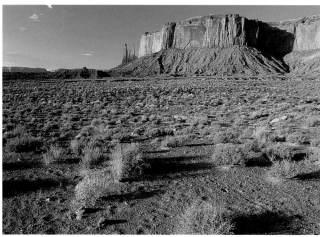

After Sunrise/Before Sunset. The one to two hours immediately after sunrise or before sunset are good for shooting buildings and other structures. There is still a little warmth, and the quality of light is more contrasty, showing off the details in materials and providing good color saturation.

Midday. Most of the daylight hours are unflattering for portraits because the sun's height and harshness create unflattering shadows and contrast. At noon, with the sun directly overhead, highlights are bright, shadows are dark, and colors are super saturated. It's not a flattering time for taking most portraits, landscapes, and buildings, but it can be effective.

These four images were created using the early morning light within the first hour after sunrise.

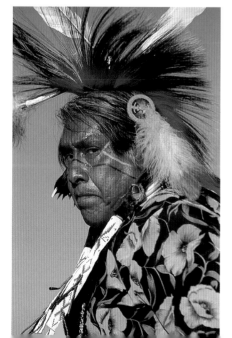

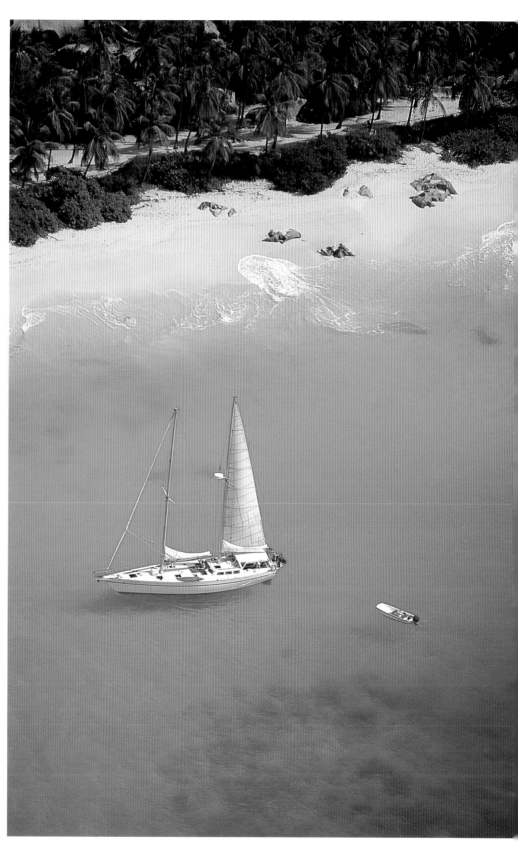

Although most of the daylight hours are unflattering for portraits, midday light produces rich and brilliant colors that work well on some subjects.

Afternoon. As it sets, the sun reverses its morning performance. Dusk can provide some interesting and unique effects. There is a half-hour time period where building lights and skylight are balanced in exposure. The mixture of the colors can be outstanding and can transform an ordinary scene into one of great beauty.

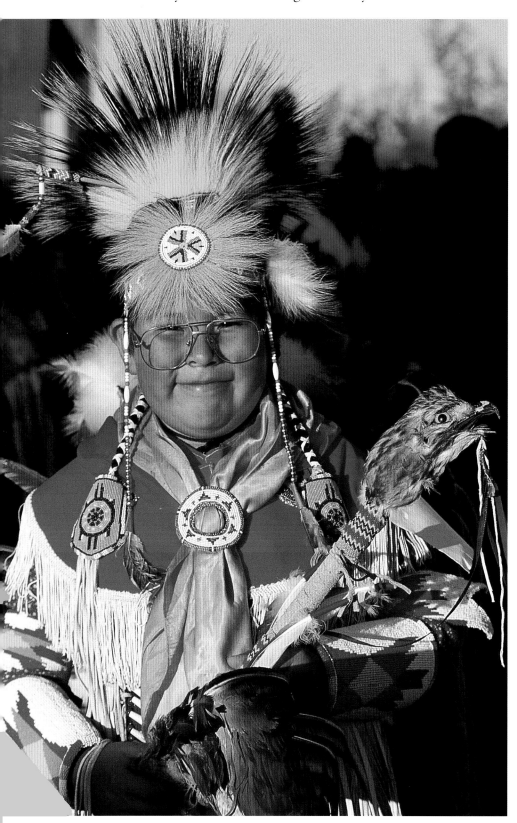

THIS PAGE AND FACING PAGE—The unique effects of late afternoon light can create a mixture of colors that transform an ordinary scene into one of great beauty.

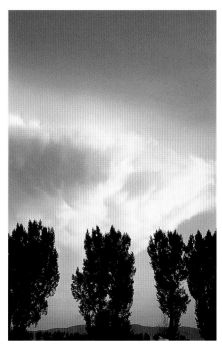

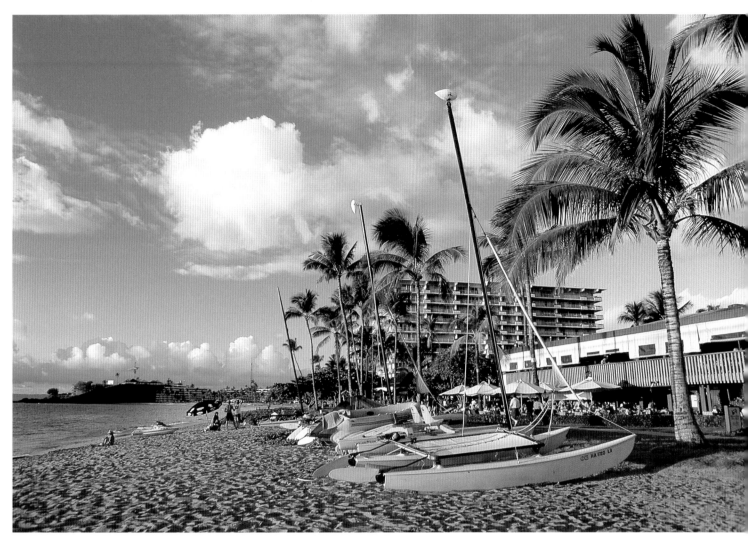

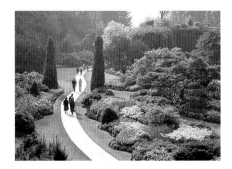

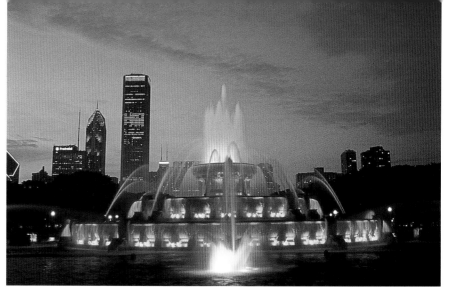

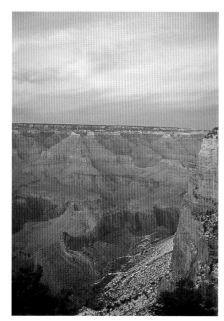

At dusk, the light in the sky can be used alone or paired with man-made light sources to create beautiful color effects.

France's Chateau Chambord photographed in the midafternoon (left) and early morning (right).

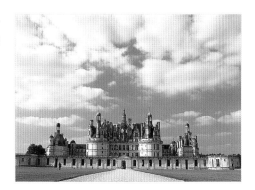 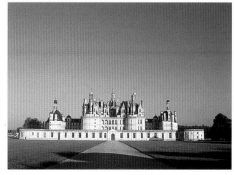

The Fire Academy in Chicago under overcast light (left) and late afternoon sunlight (right).

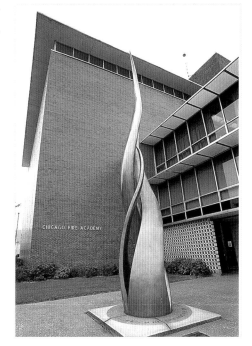 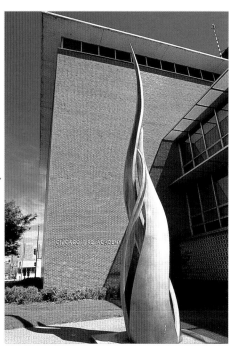

I photographed the White House Ruins in Canyon de Chelly, Arizona under hazy sky (left) and late afternoon sun (right). These two images were taken within fifteen minutes of each other when the haze blew in or burned off.

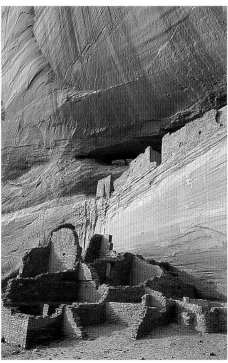 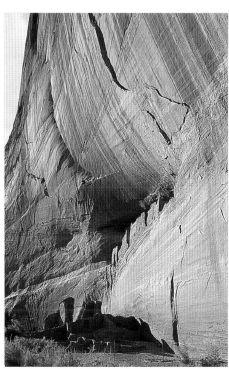

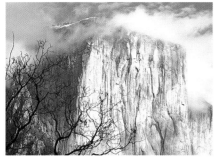 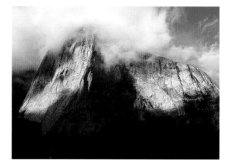

These images of El Capitan, in Yosemite, California, were taken in the midafternoon with clouds (left) and the early morning with clouds (right).

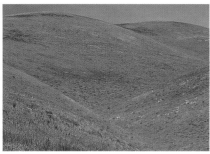 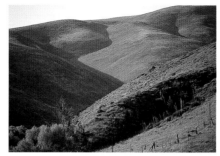

I photographed these flowered hills in mid-afternoon sunshine for bright colors (left) and late afternoon for pastel colors but more form in the hills (right).

■ WEATHER

Contrary to popular belief, there is no such thing as bad weather. I've photographed in freezing cold; torrential downpours; under such deep overcast conditions that everything looked like a two-dimensional drawing; and in rainforests so humid that my lenses had to be placed in airtight baggies with silica gel to avoid growing fungus. Photographers need to use what's available—and must find a way to do it creatively. What follows are some tips and guidelines for shooting and caring for your equipment.

Overcast Skies. Most wide landscapes require direct sunlight to show detail, texture, shape, and form. However, sometimes the scene and the mood are a perfect match. The best suggestion is to come in close and focus on the details. There will be good color saturation—subtle, not brilliant—and the soft light will provide plenty of detail.

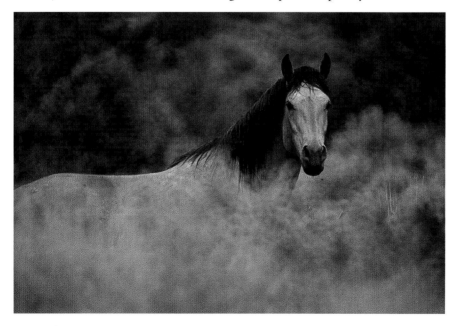

This wild mustang was photographed under thick overcast skies.

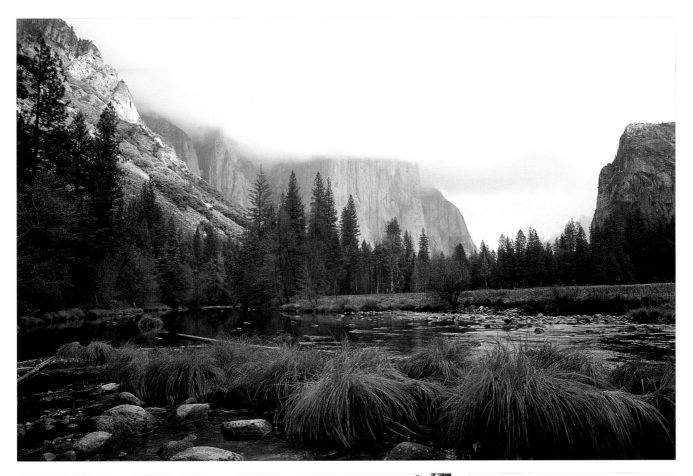

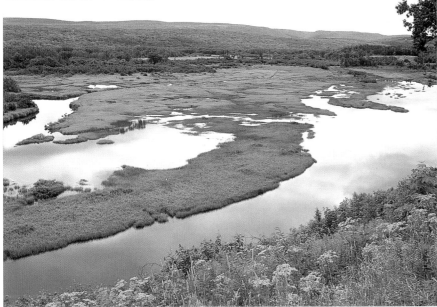
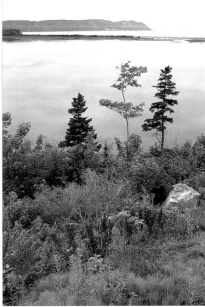

TOP—I photographed the Merced River, in Yosemite, California under an overcast sky with clouds. BOTTOM PAIR—These images of rivers and the bay landscape in Cape Breton Island, Nova Scotia, Canada, were also made under overcast skies.

Rain, Sleet, and Snow. Use slow shutter speeds to capture the blur of the precipitation. Always keep a bath towel or a roll of paper towels in your car, and a small towel in your bag. Moisture on your camera is not damaging for short periods of time. However, dunking your camera in the water is definitely *not* recommended.

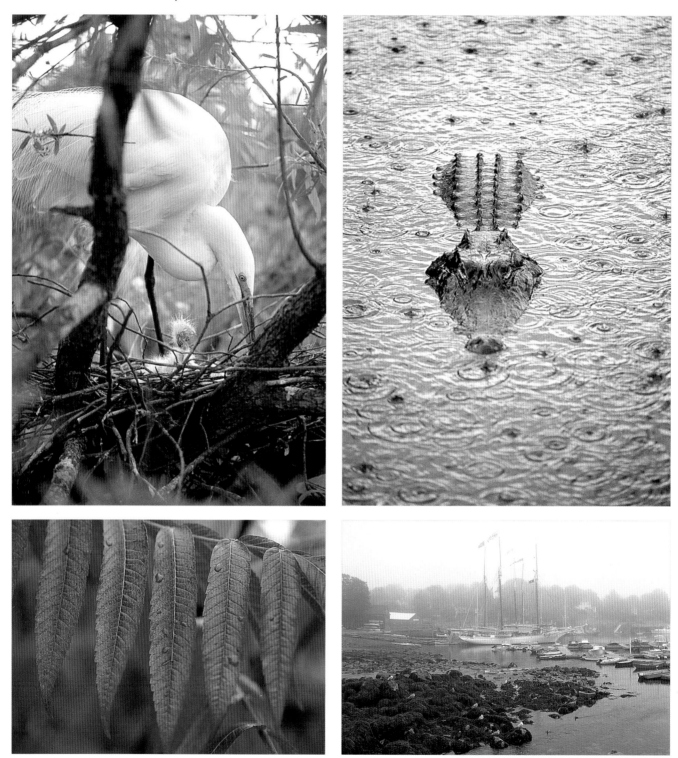

TOP LEFT AND RIGHT, BOTTOM LEFT—All of these images were shot in the rain. BOTTOM RIGHT—Camden Harbor, Maine, shot through fog.

Saltwater. Shooting around saltwater is lethal for camera equipment. There are watertight bags made especially for these conditions. At the very least, keep your camera in a plastic bag. Poke a hole in the bag for the lens and tape it around your camera tightly. Use a UV filter to protect the front element of your lens. You should also have on hand a cloth dampened with fresh water to wipe off the salt.

LEFT—This image was taken from a dingy traveling next to a sailboat. RIGHT—I took this photo while standing in the water. I used a wide-angle lens with a polarizing filter.

Freezing Temperatures. Cold won't hurt your camera gear or film, but your batteries won't like it much. Keep the batteries in an inside pocket until you need them. Transferring a warm camera to a cold environment, or a cold camera into a warm one can result in condensation on the lens and viewfinder. When this happens, there's not much you can do until the temperature stabilizes—although the fog can act as a diffusion filter for cool effects. In extreme cold, increase your exposure by a half-stop, since the emulsion's ability to record light slows down.

The fog in this image is the result of condensation on the lens and viewfinder, not the atmospheric conditions.

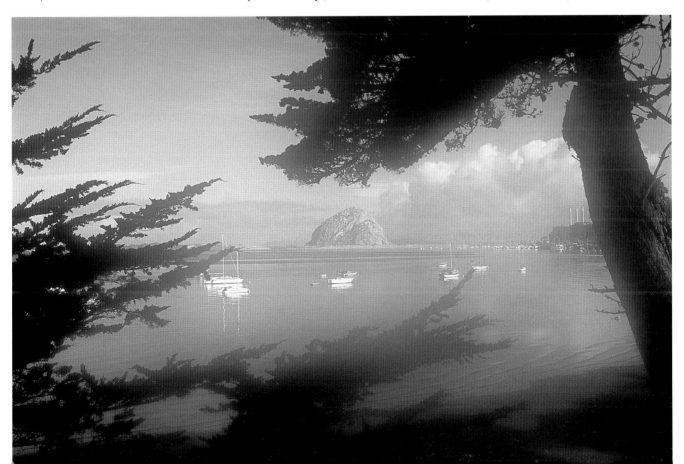

Sky Reflecting off Neutral Surfaces. Keep in mind that when there is a huge amount of sky with no direct sun, and the surrounding area is neutral, such as sand or snow, the bluish color of the sky is magnified.

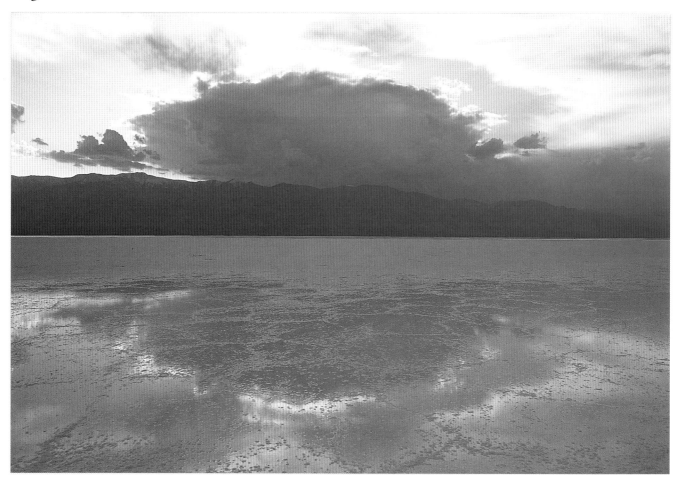

■ FLUORESCENT AND HIGH-ENERGY DISCHARGE LAMPS

Fluorescents and other lights—such as sodium vapor, mercury vapor, carbon arc, and metal halide—present special problems in recording color accurately on photographic film. They emit at different wavelengths than other light sources and require different sets of filtration. However, knowing the color temperature of these lights isn't enough information to compensate properly.

Fluorescents have a color temperature of around 4000K, which indicates a slightly warmer color than daylight. However, most fluorescent light sources are rendered greenish on daylight film and need a magenta filter to correct the temperature to 5500K. Because these sources are also single alternating-current lights, they display fluctuations in brightness and color. The most common filters used with fluorescent lighting is a 30M or 40M, which is the correction for cool-white-type bulbs—but there are many kinds of fluorescents, and each requires a different filtration. Some fluorescent bulbs are manufactured to 5500K, but because of their output fluctuation, they still require some magenta correction. The next chapter includes more information on how to solve

This image is of Badwater, Death Valley, after a rain. The sun behind the clouds paired with the skylight reflecting off the water and salt flats makes it all blue.

these problems, but the filtration correction charts for various sources and films are included on the next page. Use shutter speeds of $1/60$ second or longer for fluorescents and $1/125$ second or longer for other high-energy discharge sources.

Here, the Tiffany dome in the Cultural Center in Chicago was photographed with (left) and without (right) 30M correction.

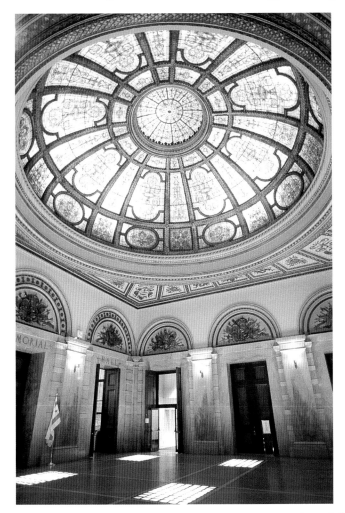 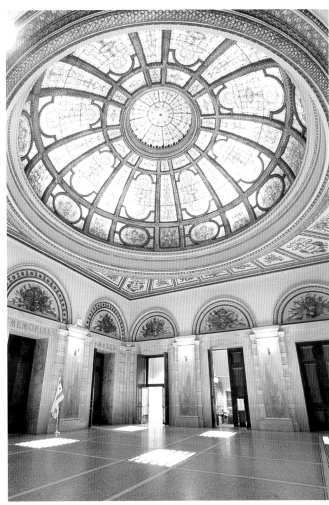

This worker in a white coat was photographed in a factory with hanging fluorescent lights. 30M correction was used to keep the white coat looking white.

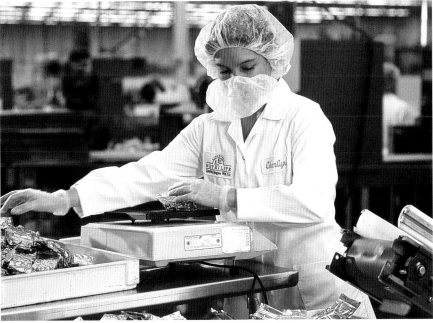

FILTERS AND EXPOSURE ADJUSTMENTS FOR KODAK COLOR FILMS WITH FLUORESCENT LAMPS

FLUORESCENT LAMP	Daylight Film								Tungsten Film (3200°K)
	PROFESSIONAL				ELITE CHROME, BRIGHT SUN, BRIGHT SUN & FLASH MAX VERSATILITY ROYAL GOLD	PROFESSIONAL EKTACHROME	KODACHROME 64	KODACHROME 200 KODACHROME 200 PROFESSIONAL	EKTACHROME PROFESSIONAL (TUNGSTEN)
	SUPRA 100	SUPRA 400	SUPRA 800, PORTRA 800, MAX VERSATILITY PLUS	PORTRA 160 NC/VC, 400 NC/VC					
Daylight	40R +1/3 stops	30R + 5M +1/3 stops	40R +1/3 stops	20R + 5M +1 stop	40R +2/3 stop	50R +1 stop[1]	50R + 10M +1/3 stops	30R +2/3 stop	no. 85B + 40M + 30Y, +1 1/2 stops
White	30B + 10M +1/3 stops	30C + 40M +1 1/2 stops	30C + 40M +1 1/3 stops	40B + 5C +1 1/3 stops	20C + 30M +1 stop	40M +2/3 stop	20C + 40M +1 stop	10B + 5M +2/3 stop	50R + 10M +1 1/2 stops
Warm White	50B +2 stops	60B +2 1/3 stops	50B + 5C +2 stops	40B + 40C +2 stops	40B +1 stop	20C + 40M +1 stop	20B + 20M +1 stop	40B + 5C +1 1/3 stops	50M + 40Y +1 stop
Warm White Deluxe	40B + 40C +2 stops	55B + 40C +2 1/3 stops	40B + 40C +2 stops	40B + 40C +2 stops	30B + 30C +1 1/3 stops	30B + 30C[2] +1 1/3 stops	40B + 5C +1 1/3 stops	10B + 50C +1 1/3 stops	10R +1/3 stops
Cool White	5B + 20M +1 stop	5C + 30M +1 1/3 stops	30M +1 stop	30B +1 stop	30M +2/3 stop	40M + 10Y +1 stop	40M + 10Y +1 stop	20M +2/3 stop	60R +1 1/2 stops
Cool White Deluxe	20B + 20C +1 stop	20B + 20C +1 1/3 stops	20B + 20C +1 stop	40C + 10M +1 stop	20C + 10M +2/3 stop	20C + 10M +2/3 stop	5B + 10M +2/3 stop	5B + 20C +2/3 stop	20M + 40Y +1 stop
Average Fluorescent[3]	—	—	—	—	10C + 20M +2/3 stop	30M +2/3 stop	5C + 30M +1 stop	10B + 5C +2/3 stop	50R +1 stop
T8 741	30B + 10M +1 1/3 stops	30C + 40M +1 1/3 stops	20B + 20M +1 1/3 stops	40B + 20C +1 1/3 stops	—	—	—	—	—
T8 830	55B + 20C +2 2/3 stops	70B + 20C +3 stops	55B + 20C +2 2/3 stops	50B + 60C +2 2/3 stops	—	—	—	—	—
T8 835	40B +1 1/3 stops	50C + 40M +2 stops	40B +1 2/3 stops	40B + 40C +2 stops	—	—	—	—	—
T8 841	20B + 10M +1 1/3 stops	20C + 30M +1 1/3 stops	20B + 10C +1 1/3 stops	50C + 20M +1 1/3 stops	—	—	—	—	—

1. With Kodak Ektachrome 100 Professional Film/EPN, use +1 1/3 stops.
2. With Kodak Ektachrome 400 Professional Film/EPN, use +2 stops.
3. When the type of fluorescent lamp is unknown, try the filter and adjustments given; color rendition will probably be less than optimum.

FILTERS AND EXPOSURE ADJUSTMENTS FOR KODAK COLOR FILMS AND HIGH-INTENSITY DISCHARGE LAMPS

FLUORESCENT LAMP	Daylight Film								Tungsten Film (3200°K)
	PROFESSIONAL				ELITE CHROME, BRIGHT SUN, BRIGHT SUN & FLASH MAX VERSATILITY ROYAL GOLD	PROFESSIONAL EKTACHROME[1]	KODACHROME 64	KODACHROME 200 KODACHROME 200 PROFESSIONAL	EKTACHROME PROFESSIONAL (TUNGSTEN)
	SUPRA 100	SUPRA 400	SUPRA 800, PORTRA 800, MAX VERSATILITY PLUS	PORTRA 160 NC/VC, 400 NC/VC					
General Electric Lucalox[2]	—	—	—	—	70B + 50C +3 stops	80B + 20C +2 1/3 stops	70B + 30C +2 1/3 stops	50B + 30C +2 1/3 stops	50M + 20C +1 stop
General Electric Multi-Vapor	—	—	—	—	10R + 20M +2/3 stop	20R + 20M +2/3 stop	30R + 10M +2/3 stop	20R + 10M +2/3 stop	60R + 20Y +1 1/3 stops
Deluxe White Mercury	—	—	—	—	20R + 20M +2/3 stop	30R + 30M +1 1/3 stops	30R + 30M +1 stop	10R + 30M +1 1/3 stops	70R + 10Y +1 1/2 stops
Clear Mercury	—	—	—	—	80R +1 1/3 stops	70R +1 1/3 stops	120R + 20M +3 stops[3]	110R + 10M +2 1/3 stops	90R + 40M +2 stops
High Pressure Sodium Vapor (2700°K)	55B + 50C +2 2/3 stops	55B + 50C +2 2/3 stops	60B + 50C +2 2/3 stops	50B + 70C +2 2/3 stops	—	—	—	—	—
High Pressure Sodium Vapor (2200°K)	60B + 55C +3 1/3 stops	60B + 55C +3 1/3 stops	120C + 50M +3 1/3 stops	50R + 90C +3 stops	—	—	—	—	—
High Pressure Sodium Vapor (2100°K)	50B + 100C +3 2/3 stops	50B + 80C +4 stops	55B + 100C +4 stops	200C + 20M +4 stops	—	—	—	—	—
Metal Halide (4300°K)	5R + 20M +1 1/3 stops	5M + 5Y +1 1/3 stops	5R + 20M +1 stop	5C + 10M +2/3 stop	—	—	—	—	—
Metal Halide (3200°K)	50C + 20M +1 1/3 stops	30B + 5C +1 1/3 stops	20B + 30C +1 1/3 stops	80C + 10M +1 1/3 stops	—	—	—	—	—
Mercury Vapor (3700°K)	30M +1 stop	20B + 30M +1 1/3 stops	30M +1 stop	30B + 5C +1 stop	—	—	—	—	—

1. Exception: Kodak Ektachrome 100 Professional Film/EPN.
2. This is a high-pressure sodium-vapor lamp. The information in the table may not apply to other manufacturers' models because of differences in spectral characteristics.
3. To avoid affecting image definition and contrast, use no more than three color compensating filters. This combination, which includes four filters, is an exception.

*F*ilters are made of an optically correct translucent material. When placed in front of the lens, they block some colors of light, letting others pass to the film. Filters are made from either glass, resin, or gelatin, and meet high standards of optical quality so that no image degradation will result from their use. Filters serve various purposes and are specified according to each particular need. There are filters designed to alter the tones in black & white photography that aren't meant for color photography; filters to alter specific colors; filters to balance the light source to a particular film type; and many special-effect filters.

Some of the most common filters—such as UV, haze, polarizing, and warming filters—are most often made of glass. These are screwed into the front of the lens; therefore, various size filters are required for lenses with different diameters.

Photographic filters are made of optically correct translucent glass, resin, or gelatin. They come in many colors and intensities.

Here's how they work: A filter lightens its own color and darkens its opposite by allowing more of its own color of light to pass and blocking the opposite color. It will also lighten its own color's adjacents (those colors immediately to either side of it on the color chart), and darken its opposite's adjacents.

For example, imagine a scene of an apple tree with red apples, green leaves, blue sky, and some yellow butterflies. In black & white, almost all the tones, except the yellow, will render as middle gray. There will be little separation between the tones. Which filter would be appropriate? A lot depends upon the intent of the photographer. Is the picture about the tree? The apples? In black & white photography, we create the illusion of depth through the use of tonalities. Light areas come toward us and dark areas visually recede. In this case, if the apples are the primary focus, a red filter is the right choice. The apples, which are red, will be lighter. The butterflies will also be a little bit lighter, since yellow is adjacent to red on the color wheel. The green leaves will be slightly darker since green is adjacent to cyan. The blue sky will be darker for the same reason.

The darker the filter, the more dramatic the effect. A yellow #12 (12Y) filter changes the tones—or increases the contrast—more than a yellow #8 (8Y), which is paler. The red filters provide more contrast than the yellow ones because of their greater density. The exposure compensation for a red #25 (25R) filter is three stops; for a 29R filter, it is four stops. Compare this to a 12Y filter, which needs only one stop of compensation.

FILTERS FOR BLACK & WHITE PHOTOGRAPHY

color	filter	description	approx. exposure increase
Light Yellow	3	Partially corrects for excess blue in aerial photography.	none
Yellow	8	Darkens sky, clouds, and foliage to reproduce correct tones.	+⅓ stop
Yellowish-Green	11	Used to alter the response of panchromatic emulsions to be equivalent to the natural response of the eye to objects under tungsten illumination. Greens are reproduced slightly lighter in daylight.	+1⅓ stops
Deep Yellow	12	Minus blue filter. Can be used to cancel blue light when infrared-sensitive films are exposed. Also for penetration of haze during aerial photography.	+⅓ stop
Deep Yellow	15	Increases contrast between cloud and sky greater than No. 8, for over-correction effect. Also used for copying documents on yellowed paper.	+⅔ stop
Yellow Orange	16	Gives even greater over-correction than No. 15. Absorbs a small amount of green.	+⅔ stop
Orange	21	Contrast filter. Absorbs blue and blue/green.	+1 stop
Light Red	23A	Greater contrast effect than No. 21.	+2 stops
Deep Red	25	Greater contrast effect than No. 23.	+3 stops
Deepest Red	29	Extremely dramatic contrast.	+4 stops

Color-Correction (CC) Filters. Color-correction (or CC) filters come in all six additive and subtractive colors: red, green, blue, yellow, magenta, and cyan. They come in the following densities: .025, .05, .10, .20, .30, .40, and .50. For practical purposes, we refer to them just by the and number leave off the "point." For example, a .30 Magenta filter is referred to as a 30M, and a .20 Red filter is referred to as a 20R. These filters are used to control or change a specific color on the film that affects the entire color balance.

COLOR COMPENSATING FILTERS									
	025	05	15	20	25	30	40	50	
Cyan	Nil	⅓	⅓	⅓	⅓	⅔	⅔	⅔	Principally absorbs red
Yellow	Nil	Nil	⅓	⅓	⅓	⅔	⅔	⅔	Principally absorbs blue
Magenta	Nil	⅓	⅓	⅓	⅔	⅔	1	1	Principally absorbs green
Red	Nil	⅓	⅓	⅓	⅔	⅔	1	1	Principally absorbs blue & green
Green	Nil	⅓	⅓	⅓	⅓	⅓	⅔	⅔	Principally absorbs blue & red
Blue	Nil	⅓	⅓	⅓	⅔	1	1⅓	1⅔	Principally absorbs red & green

Many factors influence the final color of the film. These include the emulsion batch, the lighting situation, the exposure, the camera lenses used, and the processing. CC filters are used to correct for changes in the film emulsion, or a preponderance of color that affects the photo.

For example, picture a blond girl in a white dress sitting on green grass, next to a green bush, under a tree lit by skylight. A photo of this scene will certainly have an excess of reflected green light. The girl's skin tones and the shadow areas of her white dress will have a greenish cast. To correct for this, you can use a filter of the opposite color—magenta. How dense a filter you should use depends upon how much green there is. In this case, a 5M filter would probably do. Because there is so much green, this won't be enough filtration to make the green record as grayish, it will just eliminate the extra green tones. If a 50M filter was used, on the other hand, the grass probably *would* be gray—and the girl and her dress would look very pinkish-purple.

Before shooting an assignment that requires accurate color, professional advertising photographers test their film emulsion and process it at a professional E-6 lab. As noted above, the slight differences in emulsion batches can cause the final printed or reproduced results to vary from batch to batch. Therefore, if the assignment requires a lot of film, photographers usually request that their photo store hold enough film of the same emulsion for the completion of the entire job. Most professional stores provide this emulsion-holding service for free.

To test the film, the photographer sets up the scene as close as possible to what the actual shoot will be, using the same lights, set, etc., and includes a gray card and/or a color chart, like the MacBeth Color Chart, in the frame. After processing, the lab evaluates the film—especially the area of the gray card—using a densitometer. A densitometer is

Slight differences

in emulsion batches

can cause the final results

to vary from batch

to batch.

fessional series, but they also offer smaller filters that are easy to carry in a camera bag. Cokin has the "A" series (two-and-a-half inches wide for lenses with filter diameters of 36–62mm and longer than 35mm) and the "P" series (three-and-a-quarter inches wide for lenses with filter diameters of 62–112mm and wider-angle lenses). Their X-Pro series filters are 130mm x 170mm and are comparable to Lee. Cokin holders accommodate up to three filters.

"A" Series Cokin filters and filter holder.

The use of single or multiple graduated filters opens up tremendous creative options. The easiest to use are the sky filters, which are available in a wide variety of colors from blues to sunsets. They work best with a clear horizon line.

When using a sky filter, the amount of color is adjusted by moving the filter up or down in the holder. Any object that is above the line will pick up the color of the filter. For example, on an overcast day, the sky will appear white. A polarizing filter has no effect on this, and a neutral density will bring out *tone* but no *color*. By adding a graduated blue filter, the result will be both more dense and more colorful.

Many sunsets are colorless, even with clouds in the sky. By using red, orange, yellow and/or gold graduated filters, a spectacular sunset effect can be created. The addition of a stripe filter—such as coral, yellow, or pink—at the horizon line creates a setting-sun effect. The possible combinations are endless. You could use a warming filter in the foreground

Jet with blue filter (left) and with orange filter (right).

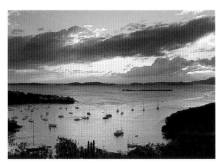 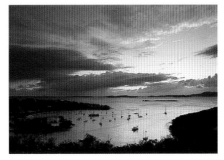 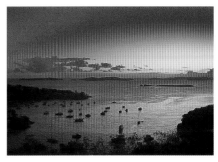

This sunset at Cruz Bay in the U.S. Virgin Islands was photographed with no filter (left), a rose filter at top only (middle), and an orange filter on bottom paired with a fluoro red filter on top (right).

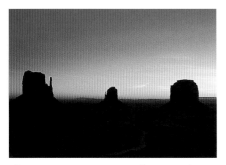 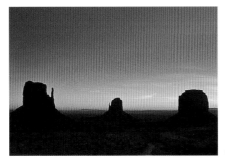 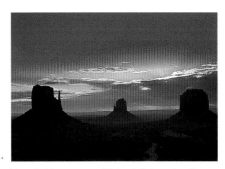

This scene at Monument Valley was photographed with a coral stripe filter paired with a blue filter (left), a sunset #2 (middle), and a fluoro red filter (right).

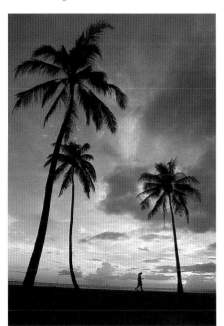 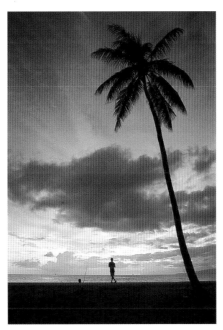 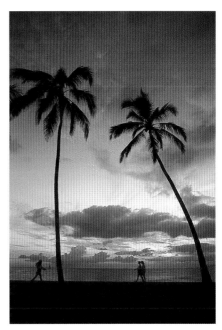

This sunset with palm trees was photographed with no filter (left) and shows some pink clouds. A rose filter at the top of the frame enhanced the clouds (center), and another variation was done by combining an orange and a rose filter (right).

to achieve the "Golden Hour" look and combine it with a blue filter for the sky. You could use neutral-density graduated filters in combination with any other filters to darken selected areas of a scene—often done to help balance the exposures in unevenly lit foreground and background areas. Take the opportunity to experiment with these filters, and you'll quickly learn how they can enhance your images.

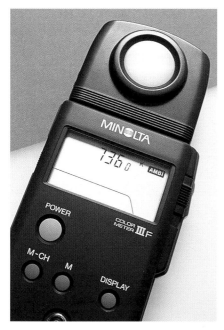 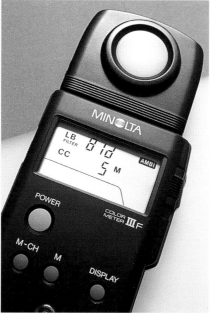

Color Temperature Meters. Color temperature meters evaluate the color of the light source and any surrounding reflected light, then give suggested filter corrections along with the exposure compensation adjustment. These meters read the three additive colors of the light source as they relate to the three layers of the color film. The meter reads incident light (the light falling on the subject), so it's necessary to be close to the subject for an accurate reading. Additionally, the meter must be set according to the film type, tungsten or daylight, in order to give accurate filter suggestions. Color temperature meters provide three types of readings: Kelvin temperature, CC, and LB (LB and conversion filters are combined under this one setting).

Sometimes the meter will just get you in the ballpark. In a factory setting, many different light sources are often used in various spaces. Therefore, readings will vary from area to area. I suggest taking several

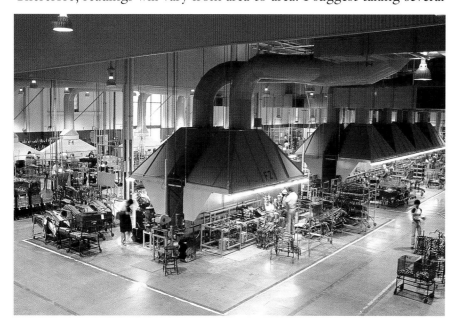

This factory shot incorporated multiple light sources, so readings varied from area to area.

readings and shooting a couple of different filter packs. After the film is processed, use the one that is the most aesthetically pleasing, because it's impossible for any of them to be completely correct. The general rule is that machinery and objects are okay if they are slightly cool, and people look better slightly warm. Pink or yellow machines just look silly, and green or blue people look like they are from outer space.

Another use of a color meter is a subjective one. Some photographers who specialize in photographing people prefer their subjects to look warm in tone. They use the color temperature meter to read the color of the light and then choose a filter that would translate into 4000K to 4500K, imitating late afternoon sunlight. This can also be done in the studio, using strobes fitted with warming gels.

■ POLARIZING FILTERS AND NEUTRAL-DENSITY FILTERS

Polarizing Filters. Polarizing filters perform several functions, including reducing reflections on shiny surfaces like water or glass, darkening the sky, and reducing haze. The filter usually has an inner mounting ring that attaches to the lens so that the outer ring holding the neutral gray glass can be freely rotated.

How polarization works is complicated, but using the filters is quite easy. As noted previously, light travels in all directions and much of it gets scattered by dust and moisture in the atmosphere. The polarizing filter eliminates the scattered light by only allowing the light that is lined up by the polarizer to pass through it. Since scattered light is in the bluish range, using the polarizer can in some situations warm up the color of the photo. It is necessary to look through the filter while rotating it in order to see when the polarizing effect happens, and the results can be quite dramatic.

Polarizing and neutral-density filters perform several functions.

To darken a blue sky, as in this image from the Grand Canyon, your shoulder must be pointed at the sun.

This pond with lily pads was shot without (left) a polarizer and with one (left). The shot with the polarizer is warmer.

An array of radio telescopes in Socorro, New Mexico, was photographed with different degrees of polarization.

When photographing the sky or water, the polarizing filter will only work when it is positioned at a right angle to the sun. Therefore, in order to darken a blue sky, your shoulder must be pointed at the sun. If the sun is positioned directly behind the camera or the subject is backlit, the polarizer will have no affect. Anywhere in between, the filter will have varying degrees of effectiveness. Be careful when using lenses wider than 28mm because the angle of view is so great that it covers more than the 90-degree rule, resulting in only part of the sky being polarized. The amount of darkening can be controlled by how much the filter is rotated. A polarizing filter is used to photograph rainbows; eliminating the scattered light allows the colors to be more saturated.

To reduce reflections on glass or other shiny surfaces, the polarizer is most useful at angles between 35 and 40 degrees. In some cases, it will not eliminate all reflections. The polarizer will not work on metallic surfaces, because metal does not polarize the light. It's almost always necessary to use a polarizing filter when photographing water, because the brightness of the reflections reduces the richness of the color. Because of its haze-reducing attributes, the use of a polarizer can also increase color saturation.

Here, you can see the effect of the polarizing filter on the window glare. This adobe building was photographed without (left) and with (right) a polarizer.

LEFT—Polarizers also work well for reducing or eliminating glare on water. RIGHT—When you use a polarizing filter with a wide-angle lens you will not get full coverage.

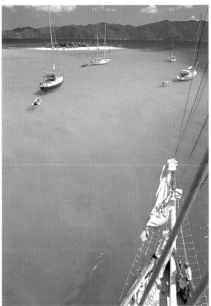

Most polarizing filters require opening up the exposure by about two stops. Some require only one-and-a-half stops, but the two-stop rule is the safest to follow. With slide film, be sure to bracket in half-stop increments both over and under. Be aware that the meter in your camera can be fooled, indicating that the exposure varies depending upon the degree of the filter's rotation. However, if you look at the filter, it is a solid, neutral-density glass, so the exposure should not vary.

There are two kinds of polarizing filters: linear and circular. Linear polarizing filters have been around the longest and work on all manual focus cameras. Most autofocus cameras have semi-silvered mirrors that require the use of circular polarizers. When used on these autofocus cameras, linear filters result in both inaccurate metering and the loss of autofocus use. Both linear and circular polarizing filters perform the same functions.

Neutral-Density Filters. Neutral-density filters come in various densities and are used primarily to reduce the amount of light that reaches the film. This allows you to use either a slower shutter speed or a wider f-stop. They are available in glass or gelatin, and the most common ones are one-stop (.3), two-stop (.6), or three-stop (.9) densities. A polarizing filter can also be used as a two-stop neutral-density filter. All of these filters are gray in appearance and do not alter the color of light at all.

■ GELS FOR LIGHT SOURCES

Gels, made of a translucent colored material, normally heat-resistant and on a polymer base, are used to change the color of the light source. Keep in mind that there is a distinct difference between the properties and function of filters and gels. Filters are optically correct and placed in front of the lens to change the color of the entire photo. Gels are not optically correct and are placed over the light source, changing only the color of that particular light.

Gels are available in all the same colors and types as filters, and come in 20" x 24" sheets. Some are also available in large roll sizes (48" x 25") for covering windows to balance the color of the light. The two best-known and most respected manufacturers are Rosco (makers of Roscolux and CalColor gels) and Lee Filters, who make both high quality filters and gels.

LEFT—Roscolux gel sample pack. RIGHT—Rosco CalColor sample pack.

Light-Balancing Gels. Although gels are available in all the same types as filters, the numbering system is a little different. The conversion and light-balancing *filters* in the bluish range, for converting tungsten to daylight, are the 80 and 82 series. In *gels*, these are called CTB (for "Color Temperature Blue"). Gels are also available in Full Blue, ¾ Blue, ½ Blue, ¼ Blue, and ⅛ Blue. A Full Blue gel placed over a tungsten light converts the color temperature to 5500K, balanced to daylight. However, if the desired effect is to keep the light slightly warm, then a ½ Blue can be used to bring the color temperature to 4300K, more like mid- to late-afternoon sunlight.

The light-balancing filters in the amber range are the 81 and 85 series. In gels, these are called CTO (for "Color Temperature Orange")

and are used to correct daylight to tungsten. A CTO placed over a strobe light converts the color to 3200K. These gels can be used to warm the light for effect. For example, in a multiple light strobe portrait setup using a main light, hair light, and background light, the photographer could choose to use a ½ or ¼ CTO on the main light to add pleasing warmth to the skin tones without affecting the color of the other lights.

BLUE GELS		
When balancing 3200°K to:	Product	Trans. Loss
5500°	Full blue (CTB)	36% (−1.5 stop)
4700°	Three-quarter blue (¾ CTB)	41% (−1.5 stop)
4100°	Half blue (½ CTB)	52% (−0.9 stop)
3800°	One-third blue (⅓ CTB)	64% (−0.6 stop)
3500°	One-quarter blue (¼ CTB)	74% (−0.4 stop)
3300°	One-eighth blue (⅛ CTB)	81% (−0.3 stop)
10,000°	Double blue (2x CTB)	10% (−3.3 stop)

Note: These filters will raise the color temperature of any source. 3200°K is used as a reference.

AMBER GELS		
When balancing 5500°K to:	Product	Trans. Loss
3200°	RoscoSun 85	58% (−0.8 stop)
2900°	RoscoSun CTO	47% (−1.1 stop)
3200°	RoscoSun ¾ CTO	58% (−0.8 stop)
3800°	RoscoSun ½ CTO	73% (−0.5 stop)
4500°	RoscoSun ¼ CTO	81% (−0.3 stop)
4900°	RoscoSun ⅛ CTO	92% (−0.1 stop)
2000°	RoscoSun Double CTO	23% (−2.1 stop)

Note: These filters will lower the color temperature of any source. 5500°K is used as a reference.

For fluorescent and discharge lamps, both Rosco and Lee carry a full line of correction gels. The gels come in either magenta—called Minus Green (equivalent to 30M)—or green—called Plus Green (equivalent to 30G). They also come in full, ½, ¼, and ⅛ increments.

The Minus Green is used to cover fluorescent lights (plain old transparent tape will do to secure them, since fluorescents don't get hot) to bring them to 5500K. The Plus Green is used in mixed-light situations where strobes or daylight must be altered to match the color of the fluorescents. In this function, a magenta filter is then placed over the lens to correct all of the color to daylight.

Gels are often used in these mixed light situations, since only one color can be corrected at a time, and all of the light sources must be balanced to one color temperature. For example, imagine you have an assignment to photograph a large open office with high ceilings, fluorescents in the ceiling, and a row of windows on one side. The standard on-camera filter correction of 30M won't work, because the daylight

TOP—Merlin was made more magical by the use of blue and green gels on the smoke around him. RIGHT—This man was photographed with a ½ CTO filter on the main light and blue, green, and purple gels on three spotlights on the wall.

coming through the window would be rendered pinkish. It would take too long and be too difficult to gel all the fluorescents—and, since it's all open, the lights would be in the photo. A compromise could be reached by using a 15M filter on the camera, correcting some of the green; but still, nothing would really be right. Here's where the long rolls of gel come in handy! The best solution is to gel the window with Plus Green, matching the window light to the green of the fluorescent lights, so now everything is 30G. Then, use a 30M filter on the camera lens to bring all the color back to 5500K or daylight.

Color-Correction (CC) Gels. Rosco makes a full line of CC gels called CalColor that come in all six colors (Red, Green, Blue, Yellow, Magenta, and Cyan), and in four densities (15, 30, 60, and 90). These are used to either add or block a specific color of the light. For example, most televisions and computer screens are 30–40C, requiring a 30–40R correction filter to balance them for daylight film. If the assignment is to photograph a person at a computer and it is important to have the monitor colors be correct, then a 30C gel is placed over the strobe light, bringing all the color in the photo to the same temperature. A 30R filter is then placed on the camera to correct everything in the scene to a normal daylight balance.

GREEN GELS TO INCREASE GREEN

MAGENTA SHIFT IS:	GEL	CC GREEN VALUE	TRANSPARENCY (LOSS)
−12	Plus Green	30G	76% (−.4 stops)
−5	½ Plus Green	15G	90% (−.2 stops)
−2	¼ Plus Green	7.5G	92% (−.1 stops)
−1	⅛ Plus Green	3.5G	93% (−.1 stops)

MAGENTA GELS TO REDUCE GREEN

GREEN SHIFT IS:	GEL	CC MAGENTA VALUE	TRANSPARENCY (LOSS)
+13	Minus Green	30M	55% (−.9 stops)
+6	½ Minus Green	15M	71% (−.5 stops)
+3	¼ Minus Green	7.5M	81% (−.3 stops)
+1	⅛ Minus Green	3.5M	88% (−.2 stops)

FILTERED SOURCE	TO TUNGSTEN	TO DAYLIGHT
Cool White	60R	30M
Cool White Deluxe	15R + 15Y	15B
Warm White	30R + 15R	30B
Warm White Deluxe	15R	30B + 30C
LP Sodium	not recommended	not recommended
HP Sodium	15B + 30M	90B
Multi-Vapor	60R + 15Y	15R + 15M
Deluxe Mercury	60R + 15Y	30R + 30M
Clear Mercury	90R + 30Y	60R + 15R

FILTER DAYLIGHT TO MATCH FLUORESCENT/DISCHARGE SOURCE

DAYLIGHT TO	DAYLIGHT SOURCE FILTRATION	LENS FILTRATION (REVERSAL FILM)[1]
Cool White	30G	CC30M
Cool White Deluxe	15Y	CC15B
Warm White	30Y + 15Y	CC30B + CC15B
Warm White Deluxe	30R + 30Y	CC30C + CC30B
LP Sodium	not recommended	not recommended
HP Sodium	90Y	CC90B
Multi-Vapor	30G + 15B	CC30M + CC15Y
Deluxe Mercury	30C + 30G	CC30R + CC30M
Clear Mercury	60C + 15C	CC60R + CC15R

1. For negative film, use overall correction in the lab. For reversal film, you can use this lens filtration as a guideline. Due to differences between filters by different manufacturers, photographic testing is strongly recommended.

PERCEPTION

This chapter deals with the perception and emotional impact of color, not the technical mixtures of RGB or the mechanics of reproduction. The theories here are used commonly in painting, graphics, and advertising and are extremely useful to the creative photographer. The information is presented simply, so that the photographer can put these ideas into effect. Many in-depth books have been written about color theory, and some of my favorites are listed in the bibliography.

There are many theories on color vision and perception, ranging from the idea that we don't see colors at all (our brain creates them based upon luminosity and spatial relations), to the thought that we have three different cones (color receptors) in our eyes, each individually receptive to one of the three additive colors. For the purposes of this book, it is not necessary to understand the biological system of our eyes. However, it is important to understand how color affects other colors and our reception of them.

Color is never what it seems. Ask a group of people to think of *red*, and they will all come up with something different. Along the same line,

Our perception of a particular color is affected by the other colors around it. In the example to the left, the center block is consistent in each example but looks brighter/darker or warmer/cooler depending on the colors around it.

What is red? A few examples are above—but ask a group of people to think of a particular color and they will all come up with something different.

asked to identify the specific color used, for example, in the Coca-Cola® logo, people would identify many different hues of red. We cannot remember a specific color, and color is always relative to its surroundings. We can accurately and scientifically measure a color but, to our eyes, it will still appear changed by what's near it. Effectively choosing colors for photography depends on a careful evaluation of the surround-

ings in order to predict the final effect of a color or colors upon the viewer.

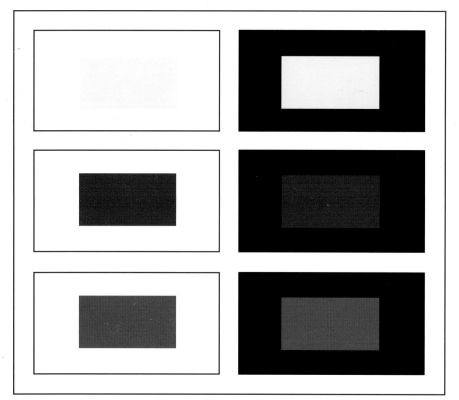

As mentioned in chapter 1, in the section on color vision, humans have the ability to adapt to different lighting systems and see basically the same color. This phenomenon is called approximate color constancy. For example, when we see human skin tones in the shade, in direct midday sunlight, or in late afternoon sunlight, the tones all look like normal skin tones to us. Film does not have this adaptive response. Photographic film is balanced to record colors accurately under just one color of light, so photographers need to be more aware of changes in light sources than the average person.

However, judging color in prints or transparencies requires a standard quality of light for consistency. Since we are looking for accuracy, based upon normal human response, we normally use daylight-balanced light sources for light tables and print viewing boxes.

■ CHARACTERISTICS OF COLORS

Three major characteristics are used to describe the attributes of color, and accurately describing a color requires all three of these characteristics together. The first characteristic, hue, is easy to define—but sometimes it's difficult to differentiate between brightness and saturation.

Hue. Hue refers to the actual color: the grass is green, the apple is red, the sun is yellow, the sky is blue. Hue is the simplest and easiest term to understand and identify. In photography, the "color" of the object is actually a reference to the color of the light that is reflecting off it. Without using filters or gels or altering the color of the light

Brightness, whether dark (above) or light (right), is a built-in characteristic.

source as perceived by the film, the hue is what it is—it's a function of the object.

Brightness. Brightness, also referred to as luminosity or lightness/darkness, is the light value of the color or how much it varies from black or white. This characteristic is separate from the hue, since we can have light red or dark red. Like the hue, brightness is a built-in characteristic—but we can alter the rendition of the brightness on film by varying our exposure. By bracketing we can make colors appear pastel by overexposing, and richer or darker by underexposing.

Saturation. Saturation describes the brilliance of the color. Is it dull or vivid? It is a measure of how much variance there is from a neutral gray of the same brightness. The quality of the light affects the saturation of a color. Hard light results in brilliant colors, soft light yields duller colors.

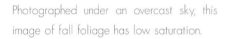

Photographed under an overcast sky, this image of fall foliage has low saturation.

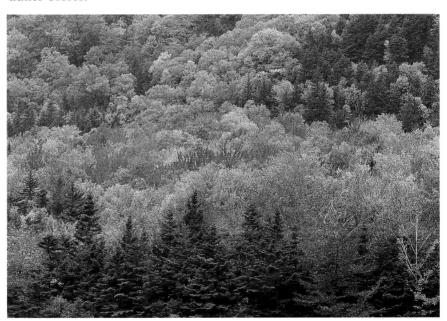

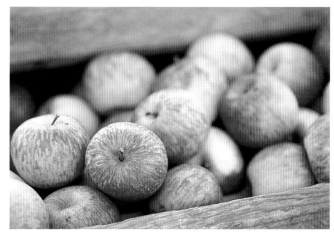

■ COLOR SYSTEMS

The following color systems are used in printing and photography to be able to identify and use colors accurately. Two of them, the Munsell System and the Twelve-Hue Color Wheel, vary from each other and the RGB systems but have very specific purposes. It's important to be familiar with all three.

The Munsell System. The Munsell System is based upon five primary hues: red, yellow, green, blue, and purple, with another five intermediate colors. The opposite of red is blue-green, the opposite of blue is yellow-red (orange), etc. The Munsell System is used for printing, since it refers to actual samples prepared from stable color pigments.

The system is a three-dimensional one, because it incorporates brightness and saturation using the terms "value" and "chroma." The values (brightnesses) are rated on a scale of 0 to 100, where 0 is black

Although both images feature red subjects, the colors are quite different. The boat (left) was photographed in bright light and the red is very saturated. The apples (right) were photographed in open shade, so the red is much less saturated.

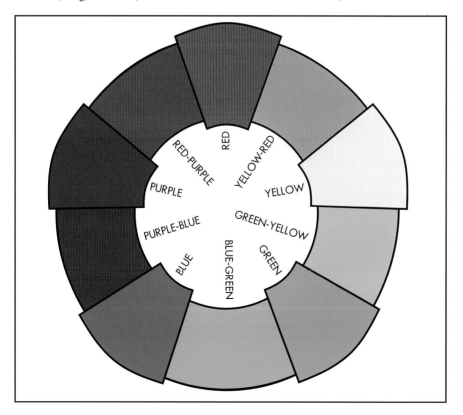

The Munsell System is based upon five primary hues: red, yellow, green, blue, and purple, with another five intermediate colors.

(or 0 percent reflectance) and 100 is white (or 100 percent reflectance). The chroma (saturation) scale is 0 for neutral gray to a high of 16, depending upon the saturation attainable from a certain hue. Not all colors can be reproduced at the maximum chroma of 16; for example, red can be reproduced at 14, and blue-green can be reproduced at a maximum chroma of 8.

Under this system, the colors are identified using the following notation: H V/C. For example, a particular blue is designated 5B 20/8 (Hue: 5 Blue; Value: 20; Chroma: 8).

The Twelve-Hue Color System. The Twelve-Hue Color System is the generally accepted system for all artistic endeavors. The primary colors are red, purple, blue, green, yellow, and orange, with six intermediary colors. The absolute primaries are red, blue, and yellow. The opposites are red-green, blue-orange, and yellow-purple. This is the system that we are taught in school; it forms the basis for the information found later in this chapter.

In the Twelve-Hue Color System, the primary colors are red, purple, blue, green, yellow, and orange. There are also six intermediary colors. The absolute primaries are red, blue, and yellow.

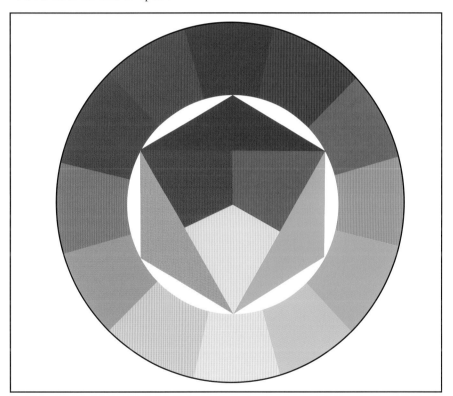

The CIE System. The CIE (Commission Internationale de l'Eclairage) is commonly called the International Commission on Illumination, and they have set the generally accepted standards for light sources and defined the "standard observer." The "standard observer" is a fictional person with average color vision and no color blindness or other abnormalities. It is on this standardized level of perception that color descriptions are based. The CIE deals with spectrum colors based upon an RGB model, and can identify almost any color by its proportions of red, green, and blue. Since the CIE incorporates the light sources such as daylight and tungsten light that can be

accurately measured, this is internationally accepted as the method of color specification.

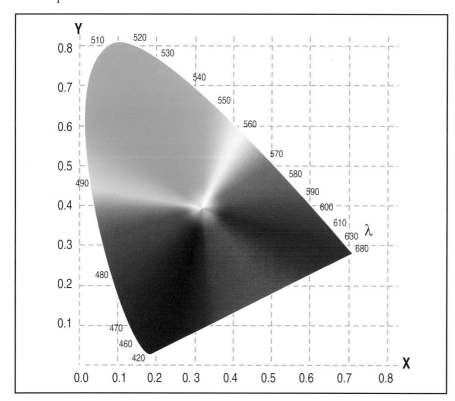

The CIE deals with spectrum colors based upon an RGB model, and can identify almost any color by its proportions of red, green, and blue.

■ COLOR HARMONY

In music, harmony refers to the blending of two, three, or four notes simultaneously for a pleasing and balanced effect. Sometimes notes are blended to create tension or discord. It is the same in color photography. The blending of certain hues creates balance or tension. Color harmony and other principles arise from the Twelve-Hue Color System. Visual artists throughout history have utilized these principals to effectively communicate the feeling of their work. The Impressionists were masters at using the subtleties of color to create the illusion of line and form without using hard lines or specific definition. Monet especially was sensitive to the colors of light and worked with cold-warm and light-dark contrasts. His paintings of the Rouen Cathedral at different times of day show his understanding and command of luminosity and shadings of saturation.

There are many color principles to consider including: contrast of hue, complementary contrast, cold-warm contrast, light-dark contrast, contrast of saturation, and simultaneous contrast. Some of these ideas overlap; for example, contrast of hue and complementary contrast can be the same.

Color harmony can be explained with an analogy to music. By combining two or more colors we create chords. If two colors are selected and occupy opposite positions in the color wheel, they are complementary colors and are harmonious. Three hues in a triangle—such as yellow, blue, and red *or* orange, green, and violet, or any triangle of the

mixed tones—are harmonious. We can also combine four colors, such as a pair of complementaries and their opposites, which creates a square on the circle and is pleasing.

Contrast of hue is combining two or more of the twelve colors. It is just the primary colors—red, blue, and yellow—luminous and saturat-

ABOVE—Contrasting primary colors (red or magenta with blue or green) creates a vigorous, intense effect. RIGHT—Contrasting secondary colors (purple and orange) creates a more subdued look.

ed, which create vigor and intensity. The secondary colors—orange, violet, and green—create a more subdued look because of their weaker characteristics. This theme of stronger and weaker colors is carried throughout all of the color principles.

Complementary contrast consists of opposites on the color wheel: yellow and violet, orange and blue, and red and green. Having the opposites present in somewhat equal amounts creates a sense of balance and completeness. These colors yield a neutral gray/black if mixed together in pigments and yield white if their light is mixed. The eye requires any color to be balanced by its opposite, so the use of complementaries is vastly important in color harmony.

Paring complementary colors (purple and yellow, blue and orange, etc.) in somewhat equal amounts creates a sense of balance and completeness.

In these red-on-green photos, we see the pairing of complementary colors of the same brightness.

Cold/warm contrast divides the colors into two groups: the blue/green/violet group and the yellow/orange/red group. There is a definite feeling of heat and stimulation in the second group, while the first creates a sense of calmness and relaxation.

Light-dark contrast is about depth. Light areas seem to leap off the page, and darker areas fade into the background. Our eye is always drawn to the lighter areas, so this is an important factor in composition. A color becomes lighter if mixed with white and darker if mixed with black. Adding either white or black to a color affects its brightness and doesn't degrade its saturation. Some colors are naturally lighter or brighter than others.

Against a cool gray background, the brightness and intensity of the yellow flowers seems enhanced.

The primary complementaries: yellow and violet, orange and blue, and red and green, have unique characteristics that are further defined by the previous two principles of warm-cold and light-dark. All fall into the warm-cold category, but their brightness values differ tremendously. Yellow is the most luminous of the colors, and violet is the darkest. A photograph with these two colors shows both principles in the extreme. Orange is not as bright as yellow, and blue is not as dark as violet, so their balance is very harmonious on both levels. Red and green, when fully saturated, are of the same value, both falling into middle gray, so there is no light-dark contrast.

When fully saturated, red and green are of the same value so there is no light-dark contrast.

Contrast of saturation is when you have colors that are not true to their natural luminosity. If a color is mixed with gray, it loses that vibrancy. The effect tones down the feeling of the color, making it more somber. A monochromatic photograph will often use the same hue throughout, but in different levels of saturation.

Simultaneous contrast is a fascinating fact. The eye requires any color's opposite for balance. If that color isn't present, the eye (or actually, the brain) will create it. This is one of the reasons why using complementary colors is so important in visual color harmony. For example, if you were to take a blue piece of paper and place a small square of gray paper on top of it, the gray would appear to have an orangish or yellowish cast. This effect also happens with two colors that are not complementary; the eye will slightly shift the colors toward the opposites. I recently experienced this phenomenon in a digital seminar where the instructor showed three identical black & white photographs side-by-side of a boy on a horse. Each horse was tinted a different color: red, green, and blue. The boy on the red horse appeared cyan; the boy on the green horse was magenta and, on the last, he was yellow. I knew that there was no physical color present on the boy, but I still perceived it.

Color deception is a function of simultaneous contrast or afterimage. If you stare for about twenty or thirty seconds at one color, when you shift your eyes to a white field, you will see the afterimage of the opposite color. Therefore, staring at a red dot results in seeing green or greenish-blue. The theory is that the red receptor cones are overstimulated, reducing their sensitivity so that, in transferring your sight to something white, the blue and green cones are activated.

■ ADVANCING AND RECEDING COLORS

In black & white photography, we create the illusion of depth with various shades of gray. Light areas have the appearance of nearness, and

Advancing colors like red and orange (left) seem to pop off the page. Receding colors like blue and green (right) create a subdued feeling.

When an advancing color is placed near a receding color, its effect is intensified. For example, a red or yellow flower on a background of green foliage is almost three-dimensional.

dark areas seem more distant. In color, the same is true—except we aren't dealing with only grays but with the brilliance and/or luminosity of colors.

In color photography, we use the warm and cool tones to define depth. The reds, yellows, and oranges are the advancing colors; they appear to pop off the page. The blues, greens, and purples are the receding colors; they seem to fade into the background. When an advancing color is placed near a receding color, its effect is intensified. For example, a red flower on a background of green foliage is almost three-dimensional.

Keep in mind that lightness and darkness are still partners here; a light-red flower on a dark-green background will create the greatest depth in this example.

Red (left) is often symbolic of power, while orange (right) suggests vitality and passion.

■ PSYCHOLOGY OF COLORS

Colors are evocative. We can be excited by red and soothed by blue. Understanding the representational feeling ascribed to certain colors is helpful to the creative photographer in setting the mood. When you adopt a monochromatic color scheme, using one basic color or hue, the inherent feeling of that color is magnified. The subtleties of brilliance and saturation will also affect the intent of the color. A dark, dull red is very different than a bright, vivid one.

RED—power, anger, love, death, danger, passion, blood

ORANGE—heat, passion, fire, vitality, intensity

YELLOW—brightness, sun, lightness, softness, cheer, warmth

GREEN—earth, balance, nature, relaxation, lushness, pride, perseverance, renewal

BLUE—peace, quiet, soothing, calmness, depth, recuperation

PURPLE—royalty, depth, mysticism, evening, completion

Blue is often associated with peace, balance, and relaxation.

Yellow (left) conveys a sense of lightness, cheer, and warmth. Purple (center) often symbolizes mysticism. Green (right) suggests renewal, lushness, and the earth.

7. BALANCING LIGHT

There is

quite a lot

to know about

this technique . . .

Dragging the shutter is a technique that balances the exposure of strobe and ambient light. Imagine you are taking a photo of someone outside at night using a portable flash, but that you also want to capture the city lights in the background. If you drag the shutter (leave it open longer than is needed to make the flash exposure), the subject will be lit by the flash, and the shutter will remain open to allow the dimmer city lights in the background to render on the film. Strobes put out a powerful amount of light, but by using a long shutter speed, we can balance it with the ambient light.

There is quite a lot to know about this technique because it involves color balance as well as exposure balance. Some cameras have a function called "slow-sync" that works with a dedicated flash and automatically reads and figures the proper shutter speed. But with a little bit of understanding, you can effectively use this technique with any camera and flash, not just the dedicated or same-system flashes.

STROBE LIGHT AND SYNC SPEED

To start, you need an understanding of how strobes or flashes work. What we refer to as a "flash" is normally a portable strobe light, whether it's built into the camera or a separate unit that is attached to the camera via a hot shoe or sync cord. A strobe is an instantaneous burst of light, a mini-explosion actually, that creates a large amount of light. The flash is so fast that it actually provides less than $1/1000$ of a second of light. Flash duration depends upon the amount of power used and normally varies anywhere from $1/500$ to $1/2000$ of a second. With some specialized studio strobes the flash duration can be as short as $1/12000$ of a second, which will freeze any action.

When taking an exposure reading with a continuous light source (anything but a strobe), we take into account both the shutter speed

and the aperture. In this case, think of light having the properties of water; the volume depends upon the size of the pipe and how long the spigot is open. In contrast, since the strobe light is on for such a short, fixed amount of time, the only control we have over the exposure is by the aperture. The shutter speed doesn't matter, because whether the shutter is open for one second or $\frac{1}{500}$ of a second, the light is only on for $\frac{1}{1000}$ of a second. Therefore, when we take exposure readings with a strobe meter, we set the shutter speed to the flash sync speed and it tells us what f-stop to use.

■ SHUTTERS AND SYNC SPEED

An important factor in this equation is the sync speed of your camera. Most 35mm cameras have focal plane shutters that consist of two curtains. One travels across the film plane, opening it to light, and the other follows the first, covering up the film plane to shield it from light. For example, if the camera is set on a one-second shutter speed, the first curtain travels from one side to the other and it stays open. Then the second curtain, one second later, travels across and covers the film plane. If you use a faster shutter speed, say $\frac{1}{500}$ of a second, the second curtain follows closely behind the first. With these faster shutter speeds, the curtains are so close together that the opening between them is narrower than the frame of film. In this case, then, the entire frame is not exposed to light all at once, but by a narrow strip of light that moves quickly across it.

On a camera with a focal plane shutter, the exposure begins when the first curtain moves across the film plane and lets light hit the film. It ends when the second curtain follows the first and closes off light. The flash synch speed is the shortest shutter speed where the space between the moving curtains is the full width of the frame.

When you use a flash, it is triggered when the first curtain reaches the opposite side. A camera's flash sync speed is the fastest shutter speed at which you can evenly expose the entire frame. At this shutter speed, when the first curtain reaches the other side and the flash goes off, the second curtain has not yet started to close. Most cameras sync at a speed of $\frac{1}{60}$. Some sync as fast as $\frac{1}{250}$. You can use any shutter speed slower than the sync speed. If you set the camera to a speed faster than your sync speed, the second curtain will be partially covering the film when the flash fires, blocking the exposure. This results in photos with a black

band at one end. How large it is will depend on how fast the shutter was.

Leaf shutters, made of blades instead of curtains, sync at any speed. This is because the flash fires when all the blades are fully retracted.

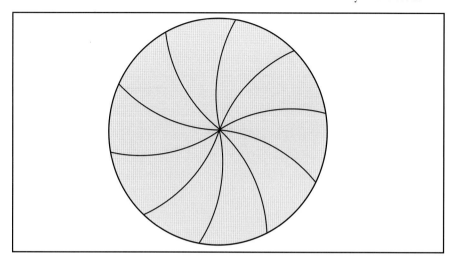

Cameras with leaf shutters can sync with the flash at any shutter speed.

■ CALCULATING EXPOSURE

When dragging the shutter, the first step is to determine your flash exposure, or what f-stop to use. All flashes these days are automatic; you set the flash to the f-stop you desire and it sends out the appropriate amount of light to achieve that. To do this, the flash uses a sensor that reads the amount of light bouncing off whatever subject you are pointing it at.

The next step is to take an exposure reading of your background light. There are two types of background lights: those that have light

In some scenes, your background elements may themselves be light sources—like computer monitors (left) or a pinball machine (right).

falling on them (such as a hotel lobby or any illuminated room), and those that are their own light source (such as city building lights, a computer screen, or the sky). In the first example you can use either a reflective or incident meter reading, which reads the amount of light falling on the subject. In the second example where the subject is a light source, you must use a reflective reading.

If you are using your in-camera meter for the background reading, I suggest using the matrix metering setting, rather than the spot setting. When you take the reading, have your camera preset to the correct f-stop and move the shutter speed dial until it tells you the exposure is correct. If you are using a handheld meter, take the flash reading first with the meter set on the $\frac{1}{60}$ shutter speed. Let's say it gives you a reading of f8. Then, take your background reading and turn your shutter speed dial until the same f-stop appears. Set the camera to whatever shutter speed it tells you.

■ AMBIENT LIGHT

You must also be

critically aware of

how much

ambient light

is falling

on your subject.

You must also be critically aware of how much ambient light is falling on your subject. If there is the same amount of light falling on your subject as in the background and you then add the flash on the subject, the subject will be overexposed. If the ambient light is two to three stops lower than the flash, it will have little effect on the subject.

■ COLOR BALANCE

The other factor that comes into play is the color of the light sources. As previously noted, photographers work with two film types: daylight, which is balanced for 5500K (bluish or cool light), and tungsten, which is balanced for 3200K (orange or warm light). Daylight and strobe are the same color temperature. Stage light, floodlight, and household light fall under the warm category, so if they are the background light sources, those subject will photograph with an orangish cast on daylight film. Similarly, daylight and strobe sources will photograph bluish on tungsten film. Sometimes this is a pleasing effect, and we don't want to correct it. Fluorescent lights and sodium-vapor, however, pose a special problem; they emit at a different wavelength than anything else, and even knowing their color temperature doesn't always help to correct the color. As a rule of thumb, most fluorescents photograph green on daylight film and require a 30M or 40M correction.

If we want the film colors to be accurate, we must use either correction filters on the camera or gels on the lights. Filters are optically correct, so we can put them in front of the lens without any degradation of the image. Gels are not optically correct and are used only over the light source. The correction filter for shooting daylight film under tungsten light is 80A, which is a bluish filter to absorb the warmth of the tungsten. The equivalent gel is called "Full Blue." The correction filter for shooting tungsten film under daylight or strobe is 85B, which is an

orangish filter to correct for the cool light. The gel is called "CTO," short for Color Temperature Orange. Both Blue and CTO gels are also available in ½, ¼, and ⅛ increments.

■ PRACTICAL EXAMPLES

Beach. Here's how I did the photos of the woman on the beach (below and facing page). First, I waited until the sun went down so there would be little light on the subject. I set up my portable flash on a stand and bounced the light into a white collapsible reflector (although any white card will do). I had a fifteen-foot sync cord running from the flash to my camera, which was mounted on a tripod.

My camera was set on manual, as was the flash. I couldn't use the flash on auto because it was pointed at the reflector. On auto, it would calculate how much light output was needed to properly expose the reflector instead of the subject.

With a handheld meter, my incident strobe reading at the subject was f5.6. I then took a reflected-light reading off the sky, turning the shutter speed dial on the meter until f5.6 appeared in the aperture box. That gave me a reading of f5.6 at ⅟₆₀ of a second. Just to check, I took an ambient incident reading from the subject and it was f5.6 at ¼ of a second, four stops different from the background reading. This meant that if I photographed the subject without the strobe, she would be a silhouette. Because the difference was so great between the ambient light and the strobe, the subject was lit just by the strobe, and the background was rendered accurately (image 1).

I did some additional things to balance the image. Since I was using daylight film, the color of the strobe light would be neutral. I wanted to warm it up, so I put a CTO gel on the strobe, simulating late after-

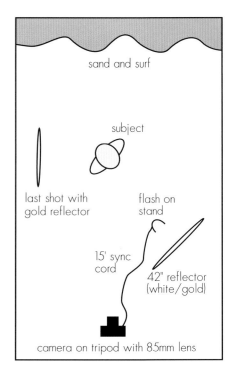

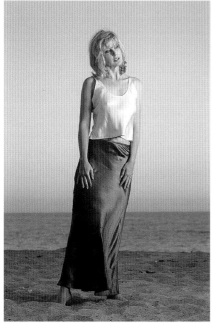

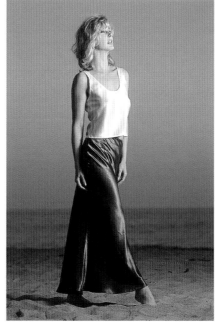

Image 1 Image 2 Image 3

Image 4

Image 5

Image 6

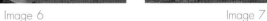

Image 7

noon light. To compensate, I had to open up the strobe reading for the color gel to f4 (image 2).

I then switched to tungsten film and shot with no filter, so the resulting photos were all bluish, both on the woman and the sky (image 3).

Then I added the CTO, which corrected the strobe light to tungsten so the subject had normal coloration (image 4). The tungsten film made the background color bluer, while the CTO on the flash corrected it to tungsten balance. I also bracketed the shutter speed several stops over and under. The faster shutter speeds rendered the background darker without affecting the amount of light on the subject. The slow-

er shutter speeds made the background lighter, bringing more ambient light to the subject (image 5). This can also cause blurring around the edge when the subject moves.

Another try was to bounce the flash into the gold side of the reflector. That also corrected the color on the woman, but the quality was more contrasty (image 6).

The light was dropping, so these exposures were varied from $\frac{1}{8}$ to $\frac{1}{60}$ of a second at the dark end of the bracketing. The last variation was to use daylight film, bouncing it into the gold reflector and using an additional gold fill (image 7).

Library. The series of photographs of the woman with the computers (below and facing page) combines balancing light and color with using the slow shutter for effect. This woman had updated the middle-school library with computers, so that was the location of the shoot. The room had high ceilings with hanging fluorescent lights. I could not light the entire room without seeing my lights, and the quality of light on he subject was flat and ugly. To get the shot, I needed to leave the room lights on to give detail (how much would depend upon the bracket), light the subject in a more flattering way, and correct the green color cast from the fluorescent lights.

If I just used the 30M correction filter on the lens, the room would be neutral but the subject would be pinkish, so I put a 30G gel on my light (a 40-degree grid spot), which made the strobe light the same color as the fluorescents. This balanced the color. To add a little warmth on the subject, I also added a $\frac{1}{2}$ CTO gel. The books were lit by built-in tungsten spots, which I did not correct. The color normally would be warm on daylight film, but with the addition of the 30M filter to correct for the color balance of the gelled strobe and fluorescents, it ren-

To get the shot,

I needed to leave

the room lights on

to give detail . . .

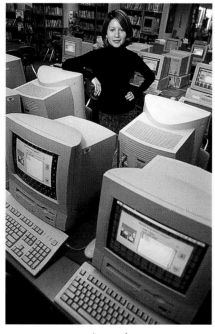

Image 1

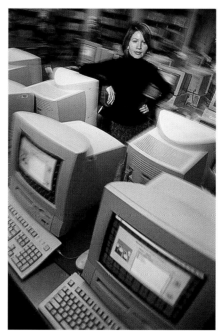

Image 2

The point

of the photo

was that the library

revolved around

the subject . . .

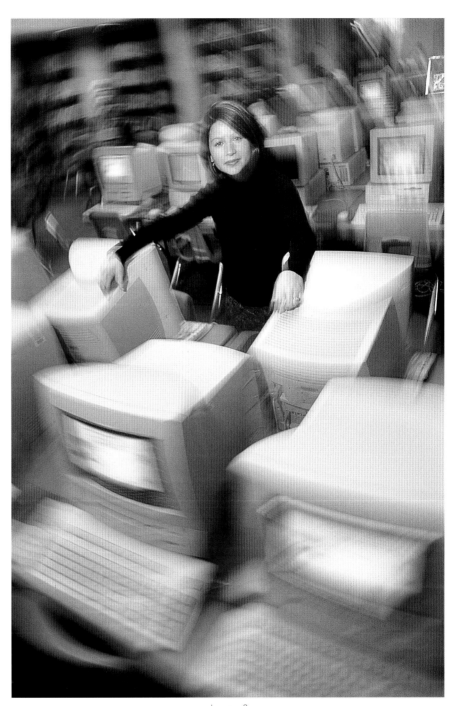

Image 3

dered as orangy-pink. The strobe reading was f/5.6, and the room read half a second. Note that the computer screen is slightly purple from the 30M filter (normal correction for computer screen or TV is about 30R), and the light on the books is orangy-pink.

Camera movement was the key to giving the image a little more character. Image 2 shows the result of slight camera shake in a handheld exposure. However, since the point of the photo was that the library revolved around the subject, I spun the camera during the final exposure (image 3). The subject is frozen by the strobe, while the ambient light provides the spinning blur.

Hospital. The nursing staff in this hospital corridor was lit by fluorescent light. I could have just filtered the lens with a 30M, but then I would have needed a slow shutter speed, and the subjects would have had to hold still instead of being able to have fun. If I just lit the scene with a strobe and set my camera to the sync speed of $\frac{1}{60}$ of a second, then the corridor behind them would be dark. Instead, I chose to use an umbrella with a 30G gel, and then put the 30M filter on the camera. The only other alternative would have been to balance the fluorescent lights to daylight with 30M gels, but that would have been very time-consuming.

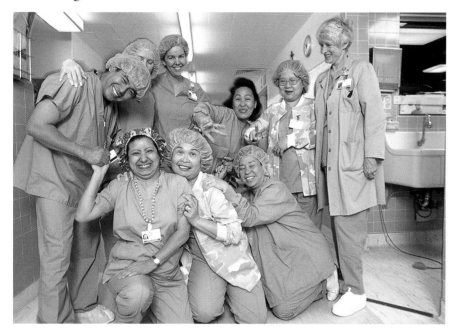

For this shot, the hospital staff was lit with strobe. The light unit was fitted with an umbrella and a 30G gel to match it to the fluorescents in the hallway. The exposure was made at f5.6 and $\frac{1}{8}$ second, with a 30M filter on the camera.

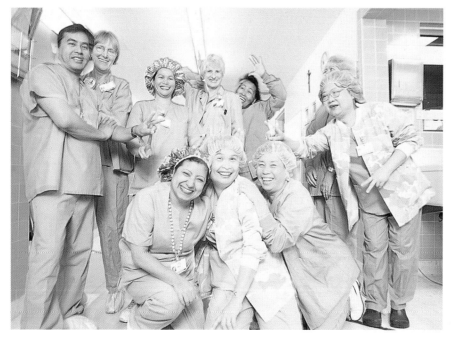

In this shot, you can see that I forgot to put on the 30M filter, but remembered to compensate for the exposure. As a result, the photo is overexposed and greenish.

Boardwalk. The girl on the boardwalk at night was lit with a Balcar battery pack strobe with a red gel on a grid spot. She was standing under a streetlight, so the exposure was affected by it as well as the strobe. The strobe was set low (f5.6) because I knew the amusement ride lights were bright (f5.6 at $\frac{1}{15}$ of a second). I had the subject move during the exposure, so she is both frozen by the strobe light and surrounded by blur from the light above.

This model was photographed on a boardwalk and was lit by a strobe that was fitted with a grid and a red gel. The model was placed under a streetlight so she is both frozen by the strobe light and surrounded by blur from the light above. The camera was handheld, and the exposure was made at f5.6 and $\frac{1}{15}$ second on 120 film.

Studio. In the studio, you have a lot more control in balancing strobe with tungsten since you can set the ratios exactly as you want them. The procedure for calculating exposure, however, is still the same as above. Start with the strobe light and take the reading for the aperture. To take the background reading, make sure the incident meter is up against the background near where the subject's head is in the viewfinder. Match the f-stop by turning the meter's shutter speed dial to the same f-stop as used for the strobe. Then, set your camera to whatever shutter speed is indicated.

For everything to be accurate, the modeling lights on the strobe must be turned off, so you will be shooting in the dark except for the

background light. Otherwise, the exposure will be lighter and the color on the subject will be warmer from the tungsten modeling tube.

The camera must be placed on a tripod for the subject and background to be sharp. If you prefer to add spin or motion effects, however, you can handhold the camera.

LEFT—A strobe power pack with one head in a medium-size box light was the main light on the woman. One 500-watt tungsten floodlight was aimed at the brown and green background. The camera was set to f8 at 1/60 second, which is the sync speed for most cameras. The background was dark because of the fast shutter speed, even though the light is on. MIDDLE—In this image, the strobe was turned off, and just the tungsten light was on. The ambient incident reading was f8 at 1/4 second. The woman is silhouetted, and the background is properly exposed, but warm, because of tungsten lighting on daylight film. RIGHT—Strobe and tungsten were combined for this shot. The modeling light on the strobe head was turned off, so the photos were shot with no ambient light on the model.

LEFT—The setup for this shot was the same as above, except that the modeling light was left on and the camera was handheld. The modeling light added both warmth from the tungsten bulb and extra exposure, making the subject's skin lighter. Tungsten and strobe lighting on her face and slight camera shake provided a frozen and blurred image of her face and shadowing around her head and body. RIGHT—A full blue (or CTB) gel was put on the tungsten background light, making the background appear more neutral. I used the same settings as above, but the modeling light was off. I employed camera shake to provide blurred edges.

8. ALTERNATIVE TECHNIQUES

The following techniques are all used for special effect. Their use constitutes creating unreality for the purpose of establishing a mood, feeling, or emotion. The interesting part is that it's impossible for the human eye to perceive this unreality; we can't see the "wrong" color, or slow motion, or even stop action. These are purely photographic effects, captured only by the camera. To produce consistent results involves testing, but the various possible outcomes can be spectacular!

◼ EXTREME PUSHING

In chapter 3, we talked about the effect of pushing film. Sometimes, pushing more than two stops can create very interesting effects. It increases pink or red, increases contrast, de-saturates the color, and

ISO 1600 film, pushed three stops, loses highlight detail and d-max.

increases grain. When the film is overdeveloped in this way, some of the emulsion is actually lifted off the film base, making it thinner so it looks grainier. A lot of the d-max is lost, too, so the film has a milky appearance.

With extreme pushing, the highlights are totally blown out and the darker and middle tones come up, but not as much. Here's the procedure for testing this: Start off with a situation containing light, middle, and dark tones. Underexpose the film by two or three stops, and push the processing three or four stops. The lighter tones will be washed out; the middle tones, since they were underexposed, will come up to normal; and the darker tones will be very saturated. Exposing normally and pushing the film this much results in losing saturation all the way around. This is a great effect with the right subject matter.

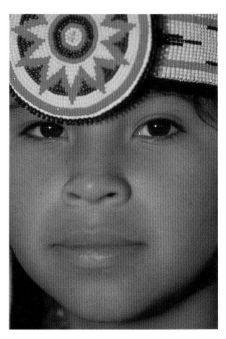

The more you push your film, the grainier and less saturated it becomes. The colors start to fade past the two-stop push. Both of these images were taken on high speed "push" film.

Kodak P-1600. Kodak P-1600 is meant to be pushed one to three stops, depending upon how it is exposed. This film is grainy, due to the larger size of the silver. It is actually a normal ISO 400 film, but it is designed to work well in the long processing times for ISO 800 and ISO 1600 film. Rating the film at ISO 3200 is not recommended, but it can still produce a usable effect. For P-1600, it is necessary to tell the lab how you rated the film; they will process it according to the manufacturer's specifications and their own testing. The more you push the film, the grainier and less saturated it becomes. The colors start to fade past the two-stop push.

Slide Films. Regular slide films are not meant to be pushed past one stop—with a few exceptions. Kodak E-200 can be pushed to two stops with little grain increase, but it may have a slight red shift. A lot of the newer slide films, from all manufacturers, have extra magenta in the emulsion for brighter colors. When these films are pushed two stops or more, they can go very red or pink, especially in the skin tones. This can

be corrected somewhat with additional washing, but the lab will determine that.

■ OVEREXPOSURE

Overexposing negative and slide films creates similar effects, but presents different problems. When negative film is overexposed by one or two stops, it increases the color saturation and makes the print lighter. A lot of photographers like to overexpose by one stop on a regular basis, just for the color boost. However, if the negative is too dense, some mini-labs are unable to print it. When slide film is overexposed, it becomes washed out, flat, and faded. In a high-key situation (white on white), the resulting images can be beautiful and ethereal.

Quite often, images of models and actresses are intentionally overexposed by one or more stops; this makes their skin tones translucent.

Of course, all tones lighten equally, so any saturated colors will also render as less bright. Overall, it's a softer feeling, more subtle and evocative. Many current advertising photos are overexposed to get this washed-out look, because it's all about the mood. The resulting photograph isn't "accurate," but it's effective—which is all that matters.

■ MOVEMENT

The following section gives guidelines for movement techniques, but they still require testing to do well. My favorite saying, "Everything depends upon everything," is applicable here.

Camera Shake. In order to understand camera shake, we must know at what point we get it. The rule for achieving sharp images when handholding a camera is as follows: the slowest usable shutter speed is

I have sharp versions of all these images, but I prefer the effect of the camera shake.

equivalent to "1" over the length of the lens in millimeters (i.e., 50mm). For example, then, a 50mm lens can be handheld at about $\frac{1}{50}$ of a second (in practice, $\frac{1}{60}$ of a second or faster). You can hold a 105mm lens at $\frac{1}{125}$ of a second or faster, a 200mm lens at $\frac{1}{250}$ of a second or faster, etc. Slower speeds require a tripod.

This guide, of course, is for use when you are trying to hold the camera steady. To test this rule, make a circle with your thumb and middle finger, and hold it in front of your eye—as close as possible—without touching your face. Close one eye and look into the distance. You'll notice that nothing seems to move much. Now hold the same circle at arm's length and notice that everything shakes. The first position is roughly equivalent to using a 28mm lens, and the second is similar to using a 200mm lens.

With this information, you can determine when camera shake begins. The more you slow the shutter speed (compensating for exposure with the f-stop), the more camera shake will be visible in your image. The effect is disturbing, adding tension and an uneasy quality to the image. Photographing a house at twilight with camera shake, for instance, creates the impression of a haunted house. Too much shake results in blur or masses of color with no discernable shapes. This can be interesting in terms of color, but it is tough to look at an image when your eye can't find anything recognizable.

Too much shake results in blur or masses of color with no discernable shapes.

Slow Shutter Speeds. This is similar to camera shake but meant specifically here for subjects that are moving while the camera is still. These include nighttime shots of streets with cars driving by, dancers, the wind blowing flowers or leaves, etc. The same rule outlined above applies, but a lot is determined by how large the moving subject is in your frame, how fast it is traveling, and the direction in which the subject is moving in relation to the camera.

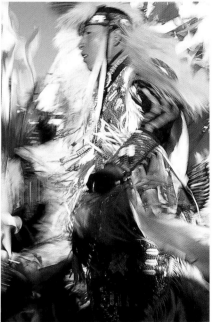

When photographing these dancers, a slow shutter speed was used to convey a sense of their motion.

Imagine, for example, that your subject is a child on a swingset. If the camera is pointed so the child is coming toward it, then the subject occupies roughly the same space in the frame throughout the entire exposure. If the camera is positioned to view the arc of the swing from the side, then the motion is moving through the frame, not in the same spot.

You will also need to consider whether the child occupies almost the full frame, half the frame, or a quarter or less of the frame. When the subject is larger, a medium-slow shutter speed ($\frac{1}{30}$ or $\frac{1}{15}$ of a second) will show movement. When the subject is smaller, a longer shutter speed of $\frac{1}{8}$ or $\frac{1}{4}$ of a second is necessary. The same goes for the movement. Side-to-side movement (across the frame) can be shown at $\frac{1}{30}$ or $\frac{1}{15}$ of

a second, whereas straight-on movement (toward or away from the camera) requires a slower shutter speed.

The last part of the equation is speed. The faster the subject, the faster the shutter speed required to show movement. For example, imagine putting your camera on a tripod perpendicular to a street. With a shutter speed of ¹⁄₁₅ of a second, a person walking would have a slight blur, a bicyclist would be a long blur, and a car would be a streak. This is a fun technique to experiment with!

Spin and Zoom. Both of these techniques refer to the intentional movement of the camera. The subject can be still or moving. Again, many factors are involved. Camera spin works best with subjects or scenes that have contrasting colors or tones. If the subject is monochromatic or the tonalities are similar, very little effect is achieved. A shutter speed of ¹⁄₃₀ or ¹⁄₁₅ of a second works best for spin, since anything slower blurs the subject past the point of recognition.

Camera spin works best with subjects or scenes that have contrasting colors or tones. In these images, camera spin was paired with a slow shutter speed.

Of course, you still need to bracket; you can see that nighttime exposures can be time-consuming, since you may be exposing for minutes at a time. For example, say your meter reading indicates f8 at ten minutes. If the f8 aperture is needed to achieve the desired depth of field, you'd need to bracket as follows: ten minutes (the dark end of the bracketing), double to twenty minutes (for the normal exposure), and then try either thirty or forty minutes (the light end of the bracketing). When you add up the exposure times, you can see that you may spend an hour to do just this one photo!

The data for reciprocity correction is available on all films from the manufacturer, either in a data sheet or on their web site.

Color Shift. Color shifts also occur with these long exposures, and this is a much more interesting topic. An old trick for photographing sunsets is to purposely use the longest shutter speed possible to enhance the strange colors. To do this, pick your smallest f-stop (like f16 or f22), and make sure the shutter speed is longer than one second. If it's too bright, wait a little while for the light level to go down, or use a neutral-density or polarizing filter to reduce the amount of light entering the camera. You'll be amazed at the results—making great images from sunsets that were actually not that spectacular.

Exposures longer than two seconds cause a color shift in film, providing richer colors than the eye could perceive.

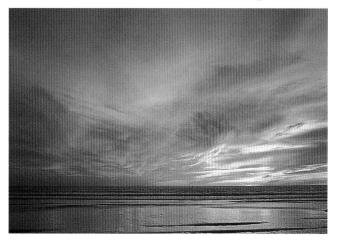
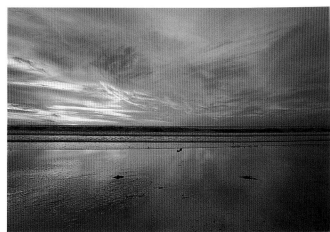

■ OUT OF FOCUS

Once, as I was examining my first exposures on a roll—you know, the pictures of your shoes or the sky, that are created as you are advancing the leader of the film—I noticed that some of the out-of-focus shots were actually kind of cool. As a result, I started playing with "cranking" the focus, setting it either in front of or behind what my normal plane of focus would be. Some of the images I created with this technique were like Impressionist paintings, and some were just trash. But I always try to do at least one frame on a roll—just to see the results. Remember, your depth of field still comes into play, so the amount you change the focus must be greater than your depth of field. I find I prefer the ones that I focus in front, or closer to the camera, than those that I focus behind.

I always try to do at least one out-of-focus frame on a roll—just to see the results.

Red leaves in focus (left) and with the focus set in front of the leaves (right).

■ EXTREME CLOSE-UP OR MACRO

A macro lens is necessary to do this technique. There are close-focus lenses that screw into the front of the lens, but these are not great quality. A macro lens has the ability to move the lens elements further away from the film plane so close-focusing is possible.

Many macro lenses are 2:1, which means that the subject will be rendered one-half life size on the film. There are a few macro lenses that are 1:1; while these can focus the subject life size on the film, you can't

shoot anything larger than a 35mm piece of film. The beauty of this is that this "limitation" opens the door to the discovery of a new world. In macro or extreme close-up images, the camera can capture subjects that you cannot actually perceive with your eyes alone.

In these pairs of close-up images, different focus points result in dramatic changes in the appearance of the image.

Because of the closeness, depth of field is negligible, even at f22. Therefore, slight changes in your point of focus can dramatically alter the emotional and graphic effect of the picture. The focusing is critical, most of the time requiring a tripod to eliminate camera shake and keep the lens in place. Patience is also required—especially for outdoor shots—because as soon as a slight breeze comes up, the focus is gone.

The blur of out-of-focus color from the reduced depth of field can be very ethereal when contrasted with one sharp point or line. Especially interesting is how colors in the background are rendered softly.

■ MISMATCHED FILMS AND LIGHTS

Choosing a film balanced for one light source, either tungsten or daylight, and shooting it under other color light sources can create interesting color effects.

Tungsten film used under daylight or strobe will be bluish. It won't be bright blue, but there will be a pale blue cast over everything. Fashion and advertising photographers use this technique to create a soft, otherworldly effect. When using this combination for portrait pho-

tography, it's advisable to overexpose the film by one-half to a full stop to clean up the skin tones and soften the colors. For landscape or still life images, you can shoot the scene normally for the added richness and color shift.

These rock formations and seed pods were photographed on tungsten film.

The other option is to use daylight film under tungsten light, which renders an image that is warm or orange. This is commonly practiced by photographers to create a homey, warm glow. Fashion photographers will shoot with floodlights or spotlights for added richness.

Sometimes, photographers combine light sources, shooting daylight film with strobes as the main light and tungsten as the background and vice versa. This can help to build that warm-cool contrast that provides a lot of depth.

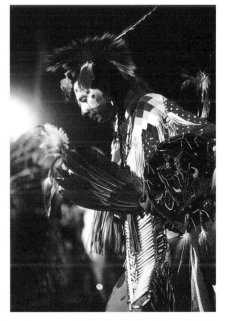

This night shot (left) was taken on Church St. in Orlando, Florida, using ISO 1600 daylight film with tungsten light. The Indian dancer (right) was photographed under floodlights at night on daylight film.

This last set of photos (below) was shot from the roof of the Sears' Tower in Chicago. The first image was shot in the late afternoon, and the skylight cast a warm glow on the buildings. After the sun set, the building lights and streetlights started to come on. The second shot was on tungsten film, causing everything to go blue. The third image was on daylight film with a 20M filter. Most building interiors are lit with fluorescents, which will render green on daylight film. In this shot, the buildings are a little too magenta, but the interior lights are okay. A 15M filter probably would have been a better choice.

Image 1

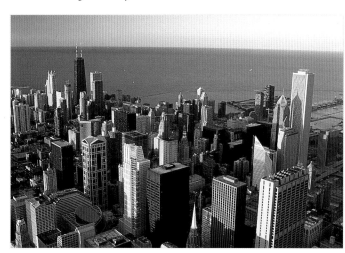

Image 2

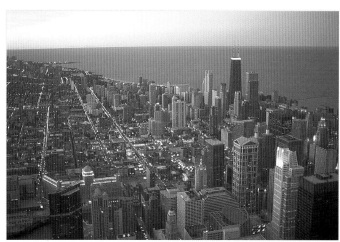

Image 3

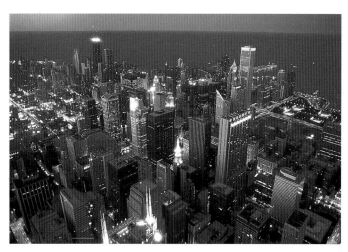

9. CROSS PROCESSING

The otherworldly colors

that result from

this process

vary greatly

from film to film.

Cross processing means developing film in the "wrong" chemistry—negative film in E-6 chemistry, and slide film in C-41 chemistry. Since it's not "normal," adjustments must be made to both the exposure and development. Keep in mind that the end result in terms of the media is determined by the chemistry used—so negative film processed in E-6 chemistry designed for slides produces a positive slide, rather than a negative.

The otherworldly colors that result from this process vary greatly from film to film. Cross processing lends wonderful effective color and can add a lot to a creative photograph. The effect in itself, although very interesting, does not make a picture good, however. When the idea for the photograph is better expressed by using weird color, though, cross processing works great.

Any lab can do this processing, although some have little or no experience with the procedure. It is not necessary to have separate tanks or do separate runs for cross-processed film. As long as 10 percent or less of a film run is cross processed, there will be no effect on the quality or replenishment of the chemistry. This is true with both E-6 "dip and dunk" machines and C-41 mini-labs. Some heavy-emulsion or heavy-silver films will have some silver retention if the secondary chemicals, the bleach and fix, are weak. Therefore, labs that do a lot of cross processing will boost the strength of these chemicals with extra replenisher, staying within normal guidelines. If silver is retained, it causes a solarized effect, which can also be really interesting.

As you'll see below, the effect of cross processing can also be enhanced with push processing.

■ NEGATIVE FILM IN E-6 CHEMISTRY

Photographing with negative film and cross processing it in E-6 chemistry produces a slide that, like every other slide, reproduces well, can be

The image on the left was shot on daylight film processed normally. The image on the right was shot on Portra 160, overexposed two stops, and push processed in E-6 two stops (+2, +2).

Daylight film was shot and processed normally for the image on the left. For the image on the right, Fuji NPS film was overexposed two stops and push processed in E-6 two stops (+2, +2).

duped, and is printed as a Type-R print. The colors that you see are what will be reproduced. It's possible to change the colors in the printing process, but it is expensive. The advantage is that most professional color reproduction processes produce better results with slides than prints.

Negative films have an orange base, and while that base is not washed away in the process, its color does shift—and this is part of what creates the color effect. The base also has a density, so you can't get a pure white.

The final coloration of the image will depend on the type of film you choose. Every film is different in terms of the colors it produces, but the results will remain consistent across a particular family of film. Kodak

Portra films, for example, because they are all on the same film base, will always be turquoise in color. Kodak Supra 100 creates peachy, lighter tones, with bluish shadow areas. Kodak Supra 400 and 800 are almost normal, with a slightly faded look. Fuji NPS is purplish. Kodak Gold has richer colors than Kodak Supra 100.

This tree with gold leaves was photographed on Kodak E 100-VS and processed normally (left), and on Kodak Supra 800 that was overexposed two stops and push processed in E-6 three stops (+2, +3) (right).

This close-up of a flower was made on Kodak Supra 800 that was overexposed two stops and push processed in E-6 three stops (+2, +3).

■ SLIDE FILM IN C-41 CHEMISTRY

Photographing with slide film and cross processing produces a negative that can then be printed as a standard Type-C print. Slide film is basically a negative film that is reversed by one of the chemicals in its intended E-6 processing, so without the reversal, it remains a negative.

However, since slide film doesn't have the orange film base of negative film, it is clear and produces crisp whites along with great shifts in color. The cross processing can especially make great reds and magentas on a bluish base. One of the chief advantages of this process is that it's easy to change the colors in the printing process. The lab can make a couple of proof sheets, one warmish and one cool, and then you can decide which way to go according to the needs of the photographic idea.

Most mini-labs can do this procedure with no problem, but they will only do their normal processing. If that's your only choice in labs, you may have to overexpose the film by one-half to one stop. Be careful about overexposing or overdeveloping too much because, even though

LEFT—E-100 S was underexposed two stops and pushed two stops in C-41 chemistry (−2, N+2). Photo by Justin Potts. RIGHT—E-100 SW was used with strobe lights and a purple gel on background, then overexposed by half a stop and processed normal (+½, N). Photo by Mick Cukurs.

the saturation is greater, the resulting density may be too much to print. Mini-labs don't like to adjust the exposure compensation on their machines, and with some dense negatives, the machine will refuse to print at all.

As in the case of negative film in E-6 chemistry, every film is different, and the manufacturers upgrade and change the emulsion bases every so often. Most photographers I know prefer Kodak Ektachrome Professional Plus (EPP) and Kodak E-100 G or GX. I've shot Fuji Velvia, too, with terrific results that are yellowish-green.

■ TESTING PROCEDURES

All films respond a little differently; therefore, it is necessary to do testing to find the appropriate balance of exposing and developing.

Negative Film. Every negative film will give you a different color shift. Testing is a necessity to find the films you like and get the developing correct. In your testing process, I strongly suggest that you take careful notes about everything you do, including the quality of light, tonalities, exposure, etc. You will end up with a slide that has a three-stop contrast range; therefore, exposure is critical. Shoot the same subject in the same light for accurate comparison between films and developing. Bracket your exposures by a half-stop, starting with a normal exposure and working up to a three-stop overexposure. For example, imagine you are shooting Kodak Portra ISO 160. If your normal exposure at ISO 160 is f11, you would bracket as follows: f11, f8.5, f8, f5.6.5, f5.6, f4.5, f4. Shoot the entire role in that sequence, and then ask the lab to cut the film in half and push process one half of the roll at N+1 and the other half at N+2. This will give you a good indication of what kind of results you like. If the results you like best are f5.6, that means the film speed for this process with Portra 160 is ISO 40, two stops over your normal exposure (N+2).

The colors are more dramatic with more processing, so I recommend using the two-stop push (N+2). The film will be a little flatter with the N+1 processing.

To get exactly the kind of results you want, snip test each roll at whatever level of development push seems the best to you after your initial testing. In different circumstances (different lighting, subject matter, tonalities, etc.), you may like N+1.5 or N+2.5 better.

A good rule of thumb is, when shooting negative film and processing to slides, think "+2, +2"—overexpose two stops (+2) and push process two stops (N+2). This is a good starting point.

Slide Film. Since slide film has such a small exposure latitude, it's better to expose normally to get good detail. If you overexpose, you can lose a lot of detail in the highlights. Sometimes this is a cool effect, but you must be careful not to make a negative that's too dense. By pushing the film in the C-41 color print chemistry, you gain tremendous color saturation.

Testing is a necessity to find the films you like and get the developing correct.

The advantage to cross processing slides to negatives is that, when printing, the lab can alter the colors in the image by changing the filters in the enlarger to shift however you would like. It's still a good idea to do some testing, bracketing one stop, in half-stop increments, both over and under the normal exposure. You can work with the lab on the processing as well. Some people like just a little push processing, at N+1; others like the results at N+2; and some prefer the normal processing with no push at all. You have many options, and again, each film will react differently.

As a rule of thumb, when shooting slide film and processing to negatives, expose normally and push process to N+1; you'll find that this is a good starting point.

Shot on E-100 SW with strobe lighting, this image was exposed normally and processed normally in C-41 chemistry. Photo by Linda Ford.

Color infrared is a lot of fun and it can produce absolutely outstanding photographs! The colors are wild, saturated, and somewhat unpredictable and, depending upon the filter you use, you can create your own alien-looking landscapes and people. Although color infrared film is not that difficult to work with, there is a lot to know about loading, exposing, selecting filters, and handling. At over twenty dollars per roll, it's also not inexpensive—but it's worth it.

Kodak is the only manufacturer of color infrared slide film. It's called Ektachrome Infrared (EIR), and it is a normal process E-6 film. The only requirement for working with it is that the lab must turn off their infrared sensors when processing. The sensors will fog the film, causing it to look faded and flat with a warm cast to it. Some labs will do this on demand, while other busy labs may only be willing to turn off the sensors once a day, perhaps for the first run in the morning.

LEFT—Canyon de Chelly photographed on EIR film with a 12Y filter. RIGHT—The same subject and film with an 11YG (yellow-green) filter.

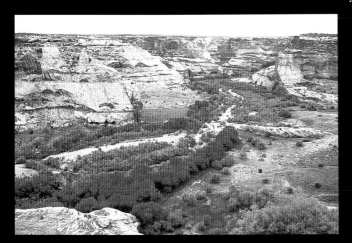 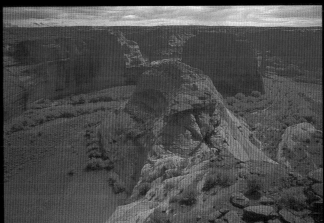

■ FOCUSING

Unlike black & white infrared film, color infrared film reacts to visible light and some ultraviolet in addition to infrared. Because it is sensitive to all of these wavelengths, it is not necessary to change the focus as you must do with black & white infrared.

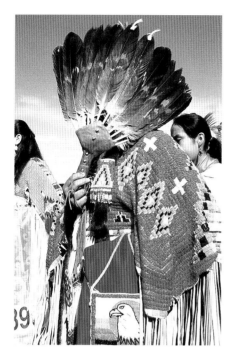

The images to the left were created on EIR film with a 12Y filter.

■ HANDLING

It's best to keep color infrared film in the refrigerator or freezer, giving it one or two hours' warm-up time in the canister before shooting. Kodak suggests that you load and unload your EIR film in darkness. Out of necessity, I have changed film on location under my jean jacket with no adverse effects, but EIR does have a greater sensitivity, so it must be handled with care.

Certain cameras have infrared sensors within them that will fog the film. This tends to happen mainly on the sprocket holes and won't harm the film. Many manufacturers offer a way to turn this feature off, so check your manuals. If you have a window on the back of the camera, I suggest covering it with at least two layers of black tape.

The film and camera manufacturers always give warnings about worst-case scenarios, but that's because they do happen. I normally find

LEFT—This showgirl and cowboy were photographed on EIR film. Unfortunately, the lab turned on its infrared sensors and fogged the film. RIGHT—The blue lines in this image (see inset) reveal that the film was scratched.

these suggestions to be a bit overboard, but you really must treat the film with care. Put tape on the canister after shooting the film and clearly label it "EIR" and "Do not open in light." The lab workers quite often automatically unload all film from canisters, so this prevents them from making that mistake.

The emulsion on EIR film is very sensitive, so it's imperative that you blow out the back of the camera to keep it free from dust. One piece of dust in the back can cause a scratch that is not only visible, but also changes color because the scratch goes through an emulsion layer. Because the emulsion is so delicate, most labs refuse to mount EIR film, since automatic mounting machines can easily scratch it. I suggest using glass mounts. I particularly like Wess Mounts; they are expensive, but high in quality and very durable.

■ CORRECT EXPOSURE AND VARIATIONS

EIR's suggested speed is ISO 200. When I first starting shooting it, I used that speed as my normal setting and bracketed in half stops up and down. However, even my darkest exposures were too light. My experience has led me to believe that the film is really better when rated at ISO 320. EIR also has a very small contrast range—about two stops. Because it is so contrasty, highlights will definitely blow out.

Shot on EIR with a 12Y in direct sun, the highlights in the image are blown out on both the man and the dancers in the background.

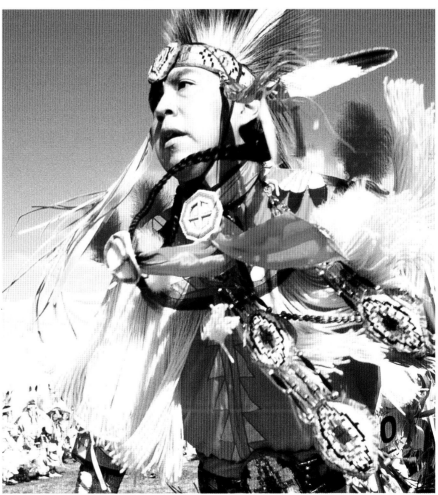

I shot these images of Sedona, Arizona, from a balloon. The first image (top left) was created on daylight film. Note the haze in the distance. The second image (top right) was shot on EIR film with no filter and exposed at +½. For the thrid image (bottom left) a 12Y filter was added, and the image was normally exposed. For the final image (bottom right), a 12Y filter was added and the image was exposed at −½. The result was a huge change in the color rendition and saturation.

LEFT—The Socorro radio telescopes were photographer on EIR with a 12Y filter, and exposed at −½ stop. RIGHT—With the same film, the telescopes were photographed using a 1YG (yellow-green) filter, and exposed at −½ stop.

It is extremely important to bracket with this film. If you have one-third-stop bracketing on your camera, I suggest you use it. I normally bracket in half stops and shoot five exposures: +1, +½, N, −½, and −1. Sometimes the difference in a half-stop change of exposure is mind blowing in its improved rendering and depth of color. If I'm shooting a landscape or still life, I will favor the underexposed brackets. With people, I tend to overexpose. Skin tones at normal exposure are mot-

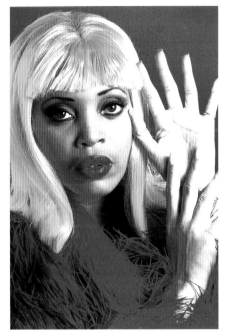

Normal daylight film and strobe lighting was used for the first image (left). The same shot was then done on EIR (middle) with a 12Y filter and exposed at +½ stop. In the third image (right), the same woman was photographed again on EIR, but this time outside in shade and with a 12Y filter.

tled and ugly. People definitely look better with lighter skin tones with less detail. I may still bracket five shots, but the normal exposure will be my darkest.

I've also found that handheld incident meters give me a better exposure than using the meter in the camera. The film can be pushed, just like any other E-6 film, but I don't recommend it because of the high level of contrast already inherent in the film.

■ COLOR SHIFTS
EIR film is sensitive to many wavelengths, but it can separate tones that would otherwise photograph as similar. This feature, as well as its ability to cut atmospheric haze, actually makes EIR an important tool for the military. Without any filter, most scenes photograph as pink or

This scene of palm trees and a pond was photographed on EIR using a 12Y filter and exposing at −½ stop.

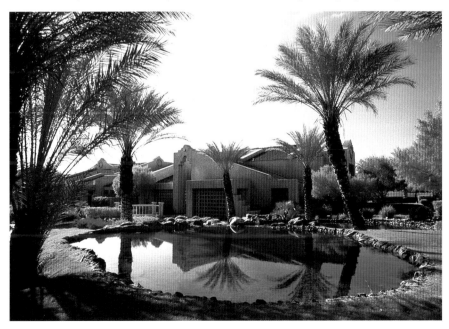

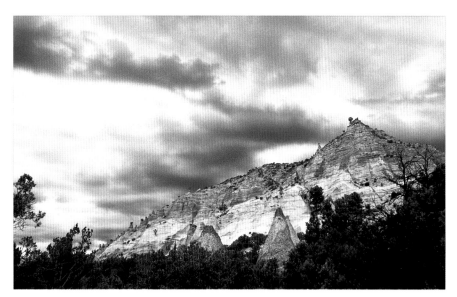

This image of Tent Rock was created on an overcast day using a 12Y filter. The result is much cooler in color than it would have been with sunlight.

magenta without much separation of other colors. People and most other subjects absorb some wavelengths of light and reflect others. Healthy plants don't absorb infrared radiation, so it is reflected back from them and captured by the film, registering as reddish. Water absorbs almost all the infrared that hits it, so it appears very dark or black. EIR will photograph cooler in the shade, both with and without filters. It also cuts haze in the distance; for this reason, it is often used for aerial photography.

■ FILTERS

The key to creating great photos on EIR is choosing the right filter. There are many that can be used, but only a few that I recommend. Only filters made for black & white photography are useful with EIR. The CC or color graduated filters will not produce much effect unless they are really dense. Because the sensitivity of the film is different than other films made for the visible spectrum, we can't treat it like normal color film. If you think of it as a black & white film you'll do better in using the filters. Another factor to consider is glass *vs.* gelatin. The gelatin filters allow more wavelengths (down to 250nm as opposed to glass at 330nm) to pass, giving more colors.

My very first roll of EIR was filled with shots of flowers and palm trees. I mistakenly chose an inappropriate filter, but achieved "happy accident" results. I had seen a few examples of EIR, and most of them were magenta overall. The information provided with the film suggested using a 12Y filter. My traditional color thinking prompted me to use an 11YG (yellow-green) filter, which is primarily green. I thought this would block the excess magenta light. Wrong! Remember, in black & white, a filter lightens its own color and darkens its opposite. What I was photographing was green in reality, so using that filter allowed *more* green light to pass, resulting in *way too much* magenta in the photo. In some cases it actually fluoresced. Since then, I've used the 11YG with very otherworldly outcomes.

My glass 12Y filter created cool tones in this photograph of a teepee.

Both of these images were shot on EIR film with an 11YG filter. The difference between them is in the exposure—the shot on the left was exposed at +½ stop, while the shot on the right was exposed at −½ stop.

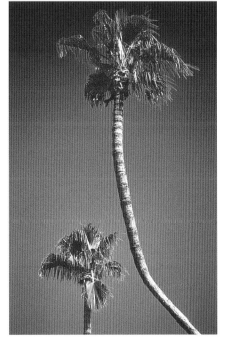
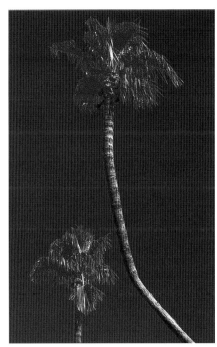

These three images were created on EIR film using a 12Y filter.

Because EIR film is sensitive to IR and UV radiation as well as to visible light, compensating for filters varies. However, *do not* compensate for the first stop of filter factor! This is tricky to understand, so let's look at a few examples. A 12Y filter requires an exposure adjustment of +1, so ignore the filter factor for EIR. If you open up, the film will be one-stop overexposed. An 11YG filter requires an exposure adjustment of +2, so for EIR you should open up only one stop. This means that if you use the light meter in your camera, you must take your exposure reading *before* you put the filter on the lens; otherwise, the camera will automatically compensate for the filter. The alternative to this is to readjust the ISO setting to read one stop faster—ISO 640 instead of ISO 320, for example.

The standard and all-around favorite filter for EIR is the 12Y. This is best for most shots, and works well for either people or objects. My next choice is 16O (orange). This works very well on people, adding a little more warmth to skin tones. As mentioned before, an 11YG filter is awesome, but the effects it creates are way out there. I've also used a 25R filter, and it seemed to suck out most of the color. Lee's 23A filter is not as dense and adds a lot of warmth. A polarizing filter is useful, too. It eliminates the scattered light, making the sky bluer and, sometimes, almost black.

The best advice is to do your own tests. Different lighting situations yield changes in color. Some subjects work better with one filter than another. I normally try many filters in any situation and look forward to seeing the results.

These flowers were photographed in the studio and lit by strobes. The first image (top left) was shot normally on daylight film. The second image was shot on EIR film with no filter and exposed at −1/2 stop. The third image (bottom left) was shot on EIR with a 12Y filter and exposed at −1/2 stop. The final image (bottom right) was shot with a 16O (orange) filter and normally exposed.

DIGITAL VS. FILM

The digital revolution is on! Just a couple of years ago, I believed that affordable, good quality digital capture was a long, long way off. Only top advertising photographers, catalog houses, and newspapers could justify the exorbitant costs—a minimum of $30,000 in camera equipment alone—for startup. But it's here now, and getting better and cheaper as you read this.

All areas of photography are affected by and moving toward digital: portrait and wedding studios, commercial and advertising photographers, editorial and magazine photographers, photojournalists, catalog houses, and fine art photographers. Film will always be with us, but the percentage of digital capture, not just digital enhancement and printing, is increasing at a rapid rate. I have no crystal ball, but I think that 80 percent of most photography will be captured digitally within the next five years. It's not a matter of "if," just "when."

The consumer versions of digital cameras are selling quickly and cheaply, and easy-to-use imaging programs used for posting on the net or sending images via e-mail are common. The professional versions are improving daily with great cameras available for around $2,000.

Don't be nervous! All of the information contained in this book applies to digital as well as film. Learning how to creatively or accurately capture an image is still important. It's much easier to add a graduated filter when shooting than to later spend hours in Adobe® Photoshop®, trying to find the right color and perfect gradation. It will always be better to shoot it the way you want it and use the manipulation programs as needed. In fact, a lot of the information in this book is necessary for you to understand in order to work with digital systems in the processes of capture, scanning, manipulation, and printing.

IMAGE CAPTURE

The digital imaging capture systems, like film, are based upon capturing red, green, and blue. Whether your camera captures those colors with a

> All of the information contained in this book applies to digital as well as film.

CCD or CMOS chip, the process relies on image sensors that are each individually receptive to only one of the RGB colors.

On the chip, these sensors are laid out in a mosaic pattern, like a tri-colored checkerboard. There are inherent problems with this arrangement. In film, we have three layers that are sensitive to each color, so in even the tiniest bit of detail, it's possible for the image to be recorded accurately in the correct color layer. In digital, each pixel captures only one color, and the mathematical calculations required to fill in the blanks are huge. This can result in artifacting and loss of image detail. The time it takes to interpolate the data can also result in a delay time when firing the shutter. Some of this can be corrected through digital enhancement after the image is transferred to a computer.

At this writing, Foveon has introduced a new image sensor, called the X3, that actually has three layers of silicon, each sensitive to either R, G, or B—just like film. The preliminary results from this chip are outstanding, resulting in three times the resolution, sharpness, and color capture. There is no artifacting, since there is no need to "fill in the blanks." Since each pixel has the ability to capture all three colors instead of one, the multi-chip or multi-scan systems, which are slow and expensive, will no longer be necessary. This will basically revolutionize the imaging business at every level, from consumer to professional.

■ ADOBE® PHOTOSHOP®

Although there are other digital manipulation programs available, Adobe® Photoshop® is the standard, and everyone from labs to service bureaus to clients use it. In fact, Adobe® Photoshop® is probably the most important tool in the current generation of photography. It has become the "digital darkroom" and provides photographers control, manipulation tools, and creative options that were never before imagined. The need for the old art of photo retouching is now gone because of the ease and precision that retouching with Adobe® Photoshop® provides. While it is an expensive and time-consuming tool, it is probably the most useful one ever available to photographers.

Despite the image-altering potential that Adobe® Photoshop® offers, I caution photographers to make the image right in the camera, with careful attention to every detail. This way, you can correct elements that were beyond your control, and not spend time correcting errors made due to carelessness.

Adobe® Photoshop® is a program that requires hundreds, if not thousands, of hours to master. Unless you are so inclined, it isn't necessary for you, a photographer, to be a skilled and proficient computer user. However, it is important for you to know what's possible so that, when needed, you can communicate with those whose job it is to be skilled Adobe® Photoshop® technicians. The many options available to users of this program are too numerous and varied to be included in this chapter. I suggest all photographers take a course in Adobe®

These sensors are laid out in a mosaic pattern, like a tricolored checkerboard.

Photoshop® to become familiar with the many things the program offers.

All of the information about color in this book is important for you to know, whether you are shooting with digital capture, or scanning original film to be manipulated in Adobe® Photoshop®.

■ COLOR BALANCE

In order to guarantee accurate color throughout the entire process of capture to output, it's extremely important to calibrate and create profiles of all your equipment: digital camera, color monitor, scanner, and printer. Otherwise, you could spend a huge amount of time correcting an image in Adobe® Photoshop® only to have the print come out looking nothing like it did on the monitor. The cost of a calibration program will be saved in wasted paper and ink costs. If you are sending digital files to a client or service bureau, your equipment will need to be calibrated for them to properly view and print the image. For accuracy over time, it's a good idea to replace your monitor every three years or so.

■ RGB AND CMYK

To put it simply, RGB is about light, and CMYK is about ink. Film relies upon the RGB systems, as does digital capture. Computer monitors emit light through RGB phosphors to create lots of colors. RGB gives us a large color gamut, or range of colors, to work with. CMYK has a much smaller gamut, due to the limitations of inks. Of course, neither system matches the wide-ranging capability of the eye. It's best to work in RGB with Adobe® Photoshop® to correct and edit, then convert to CMYK for printing. That means the monitor display changes, showing only the colors that the inks can reproduce. Since all other colors fall outside of the CMYK gamut, additional adjustments may be necessary to make up for the colors that can't be reproduced. Converting the files to CMYK requires knowing the profile of the output device, such as the type of printer that will be used.

Digital may not be cheap, but it's getting both better and more affordable. It's worth taking the time to learn the fundamentals and prepare for the future. Personally, I'm still shooting film and I expect I always will to some extent. The quality of digital still doesn't match film yet, but it will—and I'm looking forward to embracing it. I've seen the possibilities and digital is awesome. One of my friends compared shooting digital to seeing a print develop in the darkroom for the first time. Every photographer I know who has switched to digital hasn't looked back. The times, they are a-changin'. It's an exciting and magical time!

Digital may

not be cheap,

but it's getting both

better and more

affordable.

RESOURCES

■ LINKS

Adobe® Photoshop®
http://www.adobe.com/store

Epson Printers
http://www.epson.com

Foveon Technology
http://www.foveon.com

International Center of Photography
http://www.icp.org

The Julia Dean Workshops
http://www.juliadean.com

Kodak
http://www.kodak.com

Lee Filters
http://www.leefilters.com

The Maine Workshops
http://www.theworkshops.com

Minolta
http://www.minoltausa.com

Minolta/Cokin Filters
http://www.minoltausa.com/cokin/filters

The New School University
http://www.newschool.edu/index.html

Nikon
http://www.nikonpro.com/pro.htm

Photo Districts New Magazine
http://www.pdn-pix.com

PhotoFlex
http://www.photoflex.com/photoflex/index

Rosco
http://www.rosco.com

The Santa Fe Workshops
http://www.sfworkshop.com

■ ORGANIZATIONS

Advertising Photographers of America
http://www.apanational.com/

American Society of Media Photographers
http://www.asmp.org/

Editorial Photographers
http://www.editorialphoto.com/

Society of Photographic Education
http://www.spenational.org/

Women in Photography
http://www.womeninphotography.org/

■ BIBLIOGRAPHY

Albers, Josef. *Interaction of Color, Revised Edition.* (Yale University Press, 1975)

Begleiter, Steven H. *The Art of Color Infrared Photography.* (Amherst Media, 2002)

Birren, Faber. *Creative Color.* (Schiffer Publishing, Ltd., 1961, revised 1987)

Eastman Kodak Co. *Color as Seen and Photographed.* (Eastman Kodak Publication E-75, revised 1972)

Eastman Kodak Co. *The Differences between Professional Films and General Picture-Taking Films.* (Kodak Publication E-6, 2000)

Eastman Kodak Co. *Exploring the Color Image.* (Silver Pixel Press, Publication H-188, 1996)

Eastman Kodak Co. *Filtration.* (Kodak Publication H-1, 2001)

Eastman Kodak Co. *Kodak Filters.* (Kodak Publication B-AKIC, 1999)

Eastman Kodak Co. *Kodak Professional Photo Guide.* (Silver Pixel Press, Publication R)

Eastman Kodak Co. *Pathways to Color.* (Kodak Publication E-11, 2000)

Eastman Kodak Co. *Reciprocity and Special Filter Data.* (Kodak Publication E-31, Revised 2002)

Eastman Kodak Co. *Reference Data Guide.* (Kodak Publication PG-118, revised 2002)

Eastman Kodak Co. *Why a Color May Not Reproduce Correctly.* (Kodak Publication E-73, 1999)

Itten, Johannes. *The Art of Color.* (John Wiley & Sons, Inc., 1961 and 1973)

Life Library of Photography. *Color.* (Time Life Books, 1970)

Livingston, Margaret. *Vision and Art: The Biology of Seeing.* (Abrams, 2002)

Luscher, Max. *The Luscher Color Test.* (Washington Square Press, 1971)

INDEX

A

Additive colors, 17–18
Adobe® Photoshop®, 120–21
Anomalous reflectance, 22–23

B

Blur, 86–87, 89
Bracketing, 61, 114–15
Brightness, color, 69

C

Close-ups, extreme, 101–2
CMYK, 121
Color
 absorption, 22
 additive, 17–18
 advancing, 77–78
 chart, 53
 complementary, 74, 76
 contrast, 72–77
 deception, 77
 harmony, 72–77
 opposites, 22
 perception of, 12–14, 66–68
 psychology of, 78
 receding, 77–78
 reproduction failure, 22–23
 shifts with long exposures, 100
 subtractive, 18–19
Color characteristics, 66–69
 brightness, 69
 hue, 68–69

(color characteristics, continued)
 saturation, 69
Color infrared, *see* Infrared, color
Color systems
 CIE, 71–72
 Munsell, 70–71
 Twelve-Hue, 71
Color temperature, 33–48
 meters, 58–59
Color viewing kits, 21
Contrast, 72–77
Cross processing, 105–10
 exposure for, 105–10
 negative film in E-6 chemistry,
 105–7
 slide film in E-6 chemistry,
 108–9
 testing negative film, 109
 testing slide film, 109–10

D

Densitometer, 53–54
Digital imaging
 Adobe® Photoshop®, 120–21
 capture, 119–20
 color balance, 121
 color mode, 121
 vs. film, 119
Dyes, fabric, 22–23

E

Exposure
 calculating, 82–83
 cross processing, and, 105–10
 effect on color, 53
 reciprocity failure, 99–100
 when mismatching film and
 lighting, 102–4

F

Film, 9, 19–21, 24–32
 color negative, 20–21, 24
 color transparency, 25–28, 92–93
 cross processing, *see* Cross
 processing
 daylight balanced, 86
 daylight balanced with tungsten
 lighting, 103
 EIR, 111–18
 emulsion batch, 53–54
 Kodak P-1600, 92
 mismatched with light source,
 102–4
 printing, 20–21, 28
 processing, 19–21, 29–32
 professional vs. amateur, 28–29
 pulling, 29–32
 pushing, 29–32
 reciprocity failure, 99–100
 storage, 28–29
 testing, 53–54
 tungsten balanced, 84–85

(*film, continued*)
 tungsten balanced with
 strobe/daylight, 102–3
 vs. digital, 119
 warm-up time, 28–29
Filters
 color correction, 53–54
 conversion, 54
 density, 50
 for black & white, 51–52
 gelatin, 49–50
 glass, 49–50
 graduated color, 55–58
 haze, 50–51
 light balancing, 54
 neutral-density, 59–61, 62
 polarizing, 59–61
 UV, 50–51
Focus, 100
 with color infrared, 111

G
Gels, 62–65, 83–84, 86–87
Gray card, 53–54
Grid spot, 89

H
Hue, 68–69

I
Infrared, color, 111–18
 bracketing, 114–15
 color shifts, 115–16
 exposure, 113–15
 filters for, 116–18
 focusing, 111
 handling, 112–13
 metering, 115
 scratches on, 113

K
Kelvin scale, 33–34

L
Lighting
 afternoon, 38
 ambient, 83
 balancing, 80–90
 color balance, 83–84
 color of, 34–41
 fluorescent, 46–48, 63, 83,
 86–87, 88
 gels, *see* Gels
 golden hours, 35, 57
 high-energy discharge, 46–48, 63
 midday, 36
 mixed, 63–64, 86
 modeling, 89–90
 sodium-vapor, 83
 strobe, 84–85, 86–87, 89
 sunrise, 36
 sunset, 14–16, 36, 84–85
 time of day, 35–41

M
Macro images, 101–2
Meters
 color temperature, 58–59
 exposure, 82–83
Motion effects, 90, 94–99
 camera shake, 94–95
 camera spin, 97–98
 camera zoom, 97–98
 panning, 98–99
 shutter speed, 95–96
Motion, subject, 96–97

O
Overexposure, 93–94

P
Photoshop, see Adobe® Photoshop®
Printing process, 20–21, 28
Prisms, 11–12

Pull processing, 29–32
Push processing, 29–32
 extreme, 91–92
 Kodak P-1600, 92
 slide films, 92–93

R
Reciprocity failure, 99–100
Reflective surfaces, 46
Reflectors, 85–85
Reproduction failure, 22–23
RGB, 121

S
Saltwater, 44
Saturation, color, 69
Shutter
 dragging, 80–90
 focal plane, 81
 leaf, 82
 speed, 80–90, 94–95
 sync speed, 80–90
Simultaneous contrast, 76
Spectrum
 electromagnetic, 10–11
 visible, 11–12
Subtractive, 18–19
Sync speed, 80–90

V
Vision, 12–14, 66–68

W
Water, 46, 60–61
Wavelength
 scattering, 14–16
 strength, 14–16
Weather
 freezing temperatures, 44
 overcast skies, 42
 rain/sleet/snow, 43

Other Books from
Amherst Media®

Lighting for People Photography, *2nd Edition*

Stephen Crain

The up-to-date guide to lighting for portraiture. Includes: setups, equipment information, strobe and natural lighting, and much more! Features diagrams, illustrations, and exercises for practicing the techniques discussed in each chapter. $29.95 list, 8½x11, 120p, 80 b&w and color photos, glossary, index, order no. 1296.

Wedding Photography
CREATIVE TECHNIQUES FOR LIGHTING AND POSING, *2nd Edition*

Rick Ferro

Creative techniques for lighting and posing wedding portraits that will set your work apart from the competition. Covers every phase of wedding photography. $29.95 list, 8½x11, 128p, full-color photos, index, order no. 1649.

Creating World-Class Photography

Ernst Wildi

Learn how any photographer can create technically flawless photos. Features techniques for eliminating technical flaws in all types of photos—from portraits to landscapes. Includes the Zone System, digital imaging, and much more. $29.95 list, 8½x11, 128p, 120 color photos, index, order no. 1718.

Special Effects Photography Handbook

Elinor Stecker-Orel

Create magic on film with special effects! Little or no additional equipment required, use things you probably have around the house. Step-by-step instructions guide you through each effect. $29.95 list, 8½x11, 112p, 80+ color and b&w photos, index, glossary, order no. 1614.

Photographer's Guide to Polaroid Transfer, *2nd Edition*

Christopher Grey

Step-by-step instructions make it easy to master Polaroid transfer and emulsion lift-off techniques and add new dimensions to your photographic imaging. Fully illustrated to ensure great results the first time! $29.95 list, 8½x11, 128p, 50 full-color photos, order no. 1653.

Studio Portrait Photography of Children and Babies, *2nd Edition*

Marilyn Sholin

Work with the youngest portrait clients to create cherished images. Includes tips for working with kids at every developmental stage, from infant to preschooler. Features: lighting, posing and much more! $29.95 list, 8½x11, 128p, 90 full-color photos, order no. 1657.

Professional Secrets of Wedding Photography
2nd Edition

Douglas Allen Box

Over fifty top-quality portraits are analyzed to teach you the art of professional wedding portraiture. Lighting diagrams, posing information and technical specs are included for every image. $29.95 list, 8½x11, 128p, 60 full-color photos, order no. 1658.

Photo Retouching with Adobe® Photoshop®
2nd Edition

Gwen Lute

Designed for photographers, this manual teaches every phase of the process, from scanning to output. Learn to restore damaged photos, correct imperfections, create composite images and correct for dazzling color. $29.95 list, 8½x11, 120p, 60+ photos, order no. 1660.

Composition Techniques from a Master Photographer

Ernst Wildi

In photography, composition can make the difference between dull and dazzling. Master photographer Ernst Wildi teaches you his techniques for evaluating subjects and composing powerful images in this beautiful full-color book. $29.95 list, 8½x11, 128p, 100+ full-color photos, order no. 1685.

Macro and Close-up Photography Handbook

Stan Sholik & Ron Eggers

Learn to get close and capture breathtaking images of small subjects—flowers, stamps, jewelry, insects, etc. Designed with the 35mm shooter in mind, this is a comprehensive manual full of step-by-step techniques. $29.95 list, 8½x11, 120p, 80 photos, order no. 1686.

Posing and Lighting Techniques for Studio Photographers

J. J. Allen

Master the skills you need to create beautiful lighting for portraits of any subject. Posing techniques for flattering, classic images help turn every portrait into a work of art. $29.95 list, 8½x11, 120p, 125 full-color photos, order no. 1697.

Watercolor Portrait Photography
THE ART OF
POLAROID SX 70 MANIPULATION

Helen T. Boursier

Create one-of-a-kind images with this surprisingly easy artistic technique. $29.95 list, 8½x11, 128p, 200 color photos, order no. 1698.

Corrective Lighting and Posing Techniques for Portrait Photographers

Jeff Smith

Learn to make every client look his or her best by using lighting and posing to conceal real or imagined flaws—from baldness, to acne, to figure flaws. $29.95 list, 8½x11, 120p, full color, 150 photos, order no. 1711.

Make-up Techniques for Photography

Cliff Hollenbeck

Step-by-step text paired with photographic illustrations teach you the art of photographic make-up. Learn to make every portrait subject look his or her best with great styling techniques for black & white or color photography. $29.95 list, 8½x11, 120p, 80 full-color photos, order no. 1704.

Portrait Photographer's Handbook

Bill Hurter

Bill Hurter has compiled a step-by-step guide to portraiture that easily leads the reader through all phases of portrait photography. This book will be an asset to experienced photographers and beginners alike. $29.95 list, 8½x11, 128p, full color, 60 photos, order no. 1708.

Photographing Creative Landscapes

Michael Orton

Boost your creativity and bring a new level of enthusiasm to your images of the landscape. This step-by-step guide is the key to escaping from your creative rut and beginning to create more expressive images. $29.95 list, 8½x11, 128p, 70 photos, order no. 1714.

Advanced Infrared Photography Handbook

Laurie White Hayball

Building on the techniques covered in her *Infrared Photography Handbook*, Laurie White Hayball presents advanced techniques for harnessing the beauty of infrared light on film. $29.95 list, 8½x11, 128p, 100 photos, order no. 1715.

Zone System

Brian Lav

Learn to create perfectly exposed black & white negatives and top-quality prints. With this step-by-step guide, anyone can learn the Zone System and gain complete control of their black & white images! $29.95 list, 8½x11, 128p, 70 photos, order no. 1720.

Traditional Photographic Effects with Adobe® Photoshop®

Michelle Perkins and Paul Grant

Use Photoshop® to enhance your photos with handcoloring, vignettes, soft focus and much more. Every technique contains step-by-step instructions for easy learning. $29.95 list, 8½x11, 128p, 150 photos, order no. 1721.

Master Posing Guide for Portrait Photographers

J. D. Wacker

Learn the techniques you need to pose single portrait subjects, couples and groups for studio or location portraits. Includes techniques for photographing weddings, teams, children, special events and much more. $29.95 list, 8½x11, 128p, 80 photos, order no. 1722.

The Art of Color Infrared Photography

Steven H. Begleiter

Color infrared photography will open the doors to an entirely new and exciting photographic world. This exhaustive book shows readers how to previsualize the scene and get the results they want. $29.95 list, 8½x11, 128p, 80 full-color photos, order no. 1728.

Photographer's Filter Handbook

Stan Sholik and Ron Eggers

Take control of your photography with the tips offered in this book! This comprehensive volume teaches readers how to color-balance images, correct contrast problems, create special effects and more. $29.95 list, 8½x11, 128p, 100 full-color photos, order no. 1731.

Beginner's Guide to Adobe® Photoshop®

Michelle Perkins

Learn the skills you need to make your images look their best, create original artwork or add unique effects to any image. All topics are presented in short, easy-to-digest sections that will boost confidence and ensure outstanding images. $29.95 list, 8½x11, 128p, 150 full-color photos, order no. 1732.

Lighting Techniques for High Key Portrait Photography

Norman Phillips

From studio to location shots, this book shows readers how to meet the challenges of high key portrait photography to produce images their clients will adore. $29.95 list, 8½x11, 128p, 100 full-color photos, order no. 1736.

Photographer's Lighting Handbook

Lou Jacobs Jr.

Think you need a room full of expensive lighting equipment to get great shots? Think again. This book explains how light affects every subject you shoot and how, with a few simple techniques, you can produce the images you desire. $29.95 list, 8½x11, 128p, 130 full-color photos, order no. 1737.

The Best of Nature Photography

Jenni Bidner and Meleda Wegner

Have you ever wondered how legendary nature photographers like Jim Zuckerman and John Sexton create their captivating images? Follow in their footsteps as these and other top photographers capture the beauty and drama of nature on film. $29.95 list, 8½x11, 128p, 150 full-color photos, order no. 1744.

Photo Salvage with Adobe® Photoshop®

Jack and Sue Drafahl

This indispensible book will teach you how to digitally restore faded images, correct exposure and color balance problems and processing errors, eliminate scratches and much, much more. $29.95 list, 8½x11, 128p, 200 full-color photos, order no. 1751.

The Best of Wedding Photography

Bill Hurter

Learn how the top wedding photographers in the industry transform special moments into lasting romantic treasures with the posing, lighting, album design and customer service pointers found in this book. $29.95 list, 8½x11, 128p, 150 full-color photos, order no. 1747.

Success in Portrait Photography

Jeff Smith

No photographer goes into business expecting to fail, but many realize too late that camera skills alone do not ensure success. This book will teach photographers how to run savvy marketing campaigns, attract clients and provide top-notch customer service. $29.95 list, 8½x11, 128p, 100 full-color photos, order no. 1748.

Professional Digital Portrait Photography

Jeff Smith

Digital portrait photography offers a number of advantages. Yet, because the learning curve is so steep, making the transition to digital can be frustrating. Author Jeff Smith shows readers how to shoot, edit and retouch their images—while avoiding common pitfalls. $29.95 list, 8½x11, 128p, 100 full-color photos, order no. 1750.

The Best of Children's Portrait Photography

Bill Hurter

See how award-winning photographers capture the magic of childhood. *Rangefinder* editor Bill Hurter draws upon the experience and work of top professional photographers, uncovering the creative and technical skills they use to create their magical portraits. $29.95 list, 8½x11, 128p, 150 full-color photos, order no. 1752.